Coloring Book for Adults

35 Beautiful and Unique Fantasy Animal olorings with Intrinsic Patterns for Adults

SAYAKA YOSHINO

Copyright © 2016 by GoldenSloth Publishing

All rights reserved. No part of this publication may be reproduced, distributed, or transmitted in any form or by any means, including photocopying, recording, or other electronic or mechanical methods, without the prior written permission of the publisher, except in the case of brief quotations embodied in critical reviews and certain other noncommercial uses permitted by copyright law.

First of all, I want to **thank you** for buying this book. As you might know, by the purchase of this book, we offer another 20 coloring pages for free!

You can download the colorings by following this link:

http://www.goldensloth.com/go/coloring-book-landing-one/

If you enjoy our coloring books please don't forget to leave this book a review on Amazon!

This is really important to us as it will help us grow, improve our work and deliver more quality products!

Now in order to download the 35 colorings from this book, we have another download link for you so you can print them and color them as many times as you want.

https://www.dropbox.com/sh/71ms30dx00akcxy/AAAml0IiIkrfUUK3jgzAgpICa?dl=0

By following this link you can download the colourings and print them as you please.

We hope you will enjoy the colourings!
Don't forget to leave us a review!

Best regards,
GoldenSloth Publishing & Sayaka Yoshino

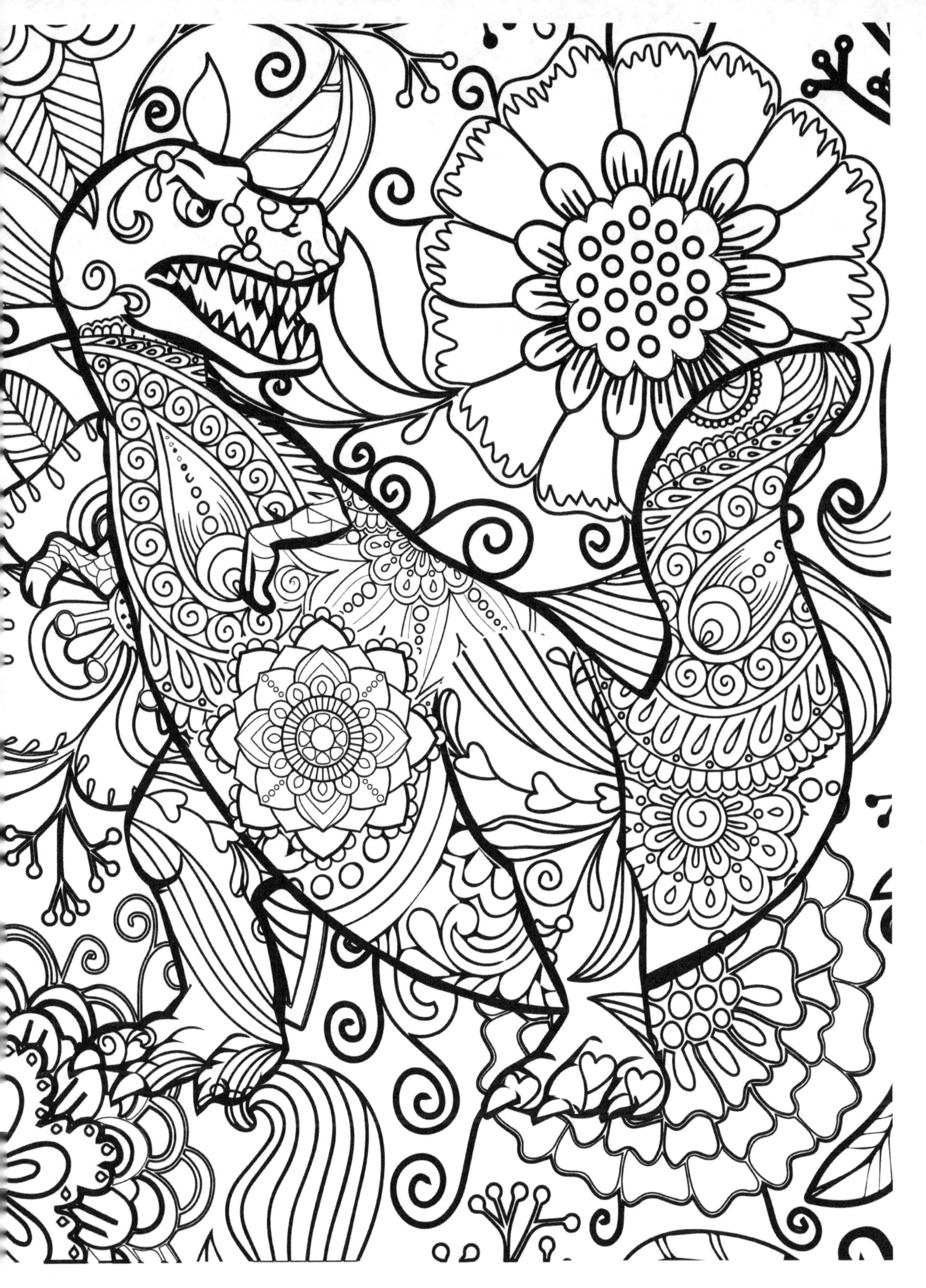

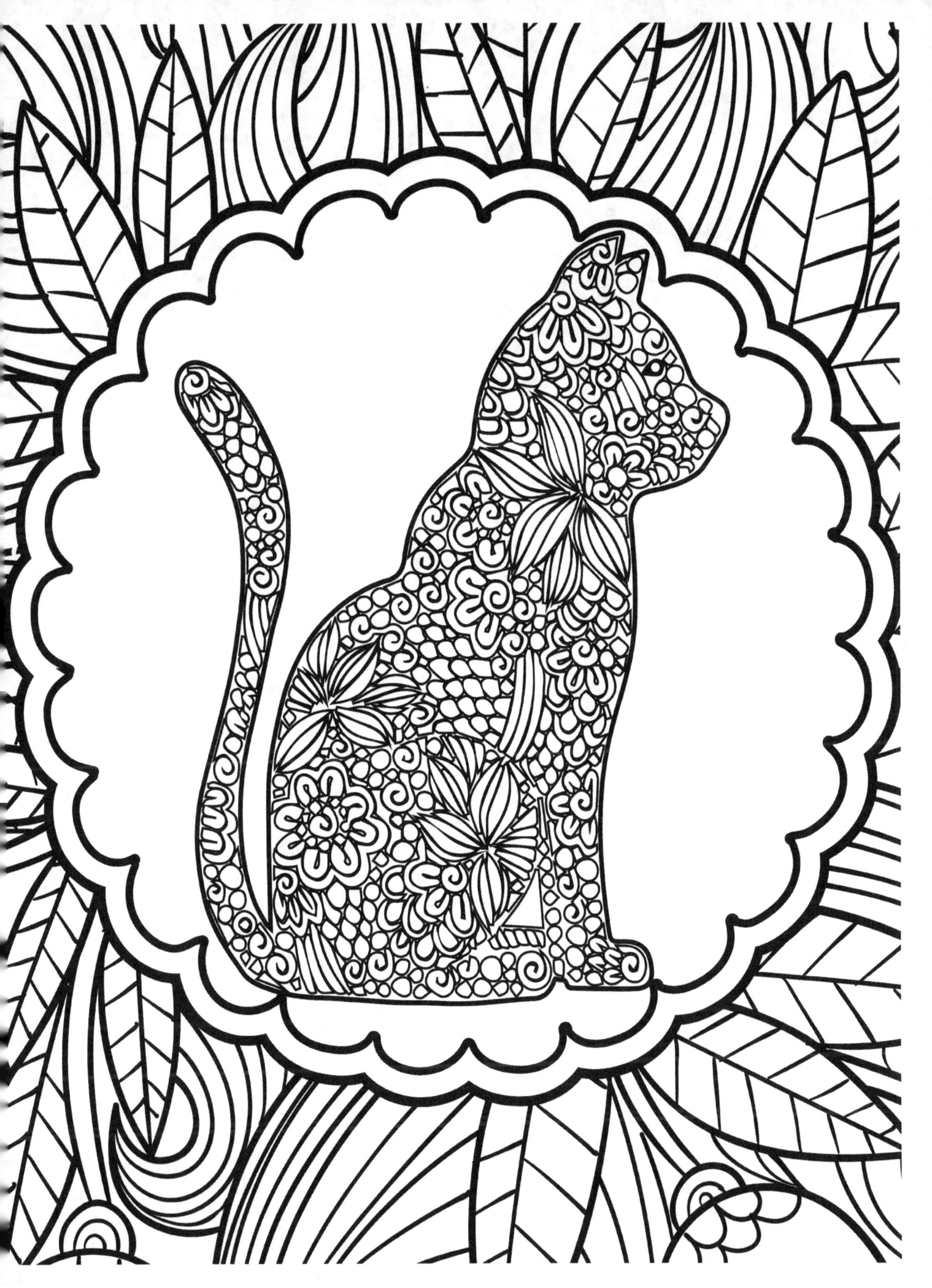

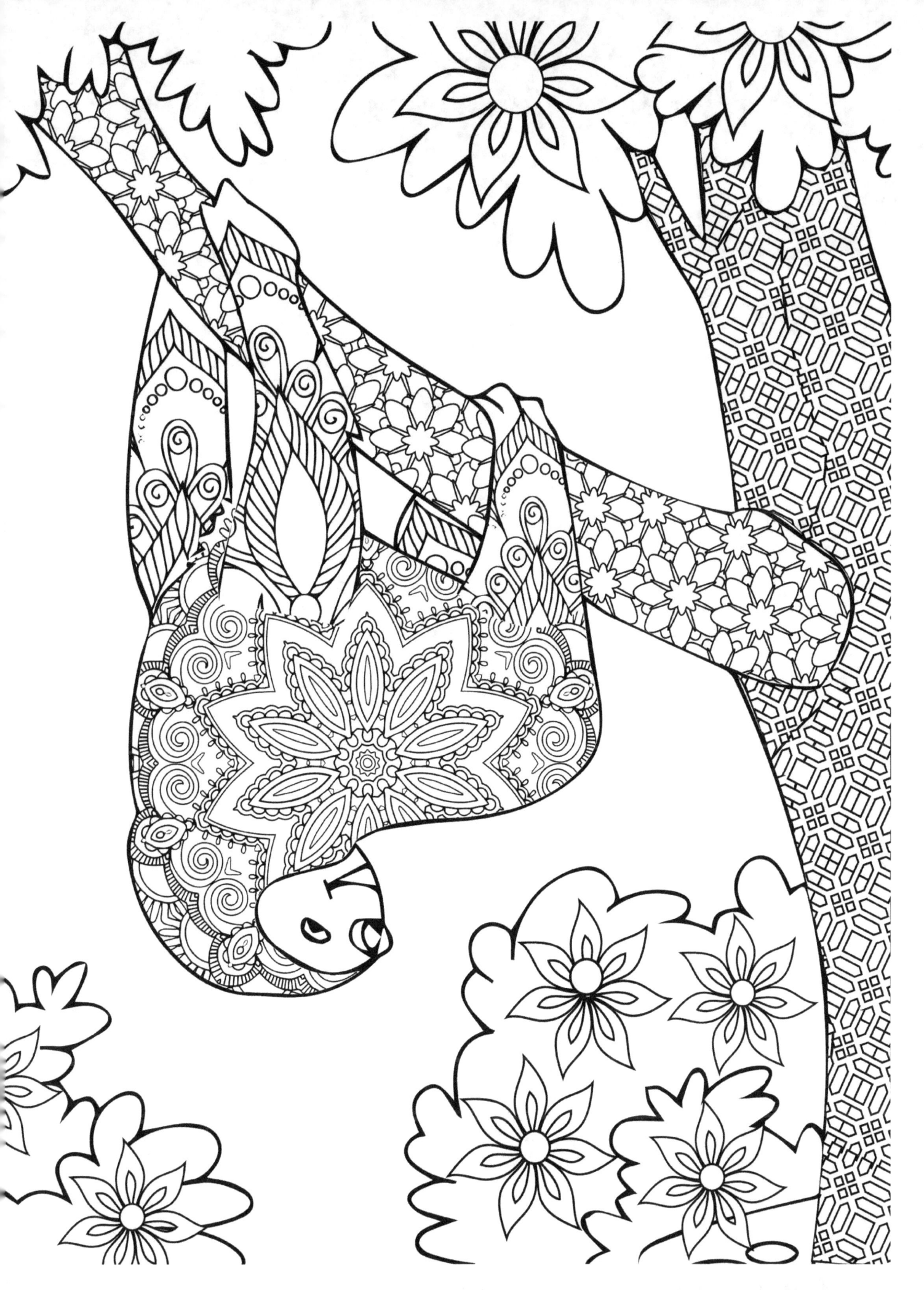

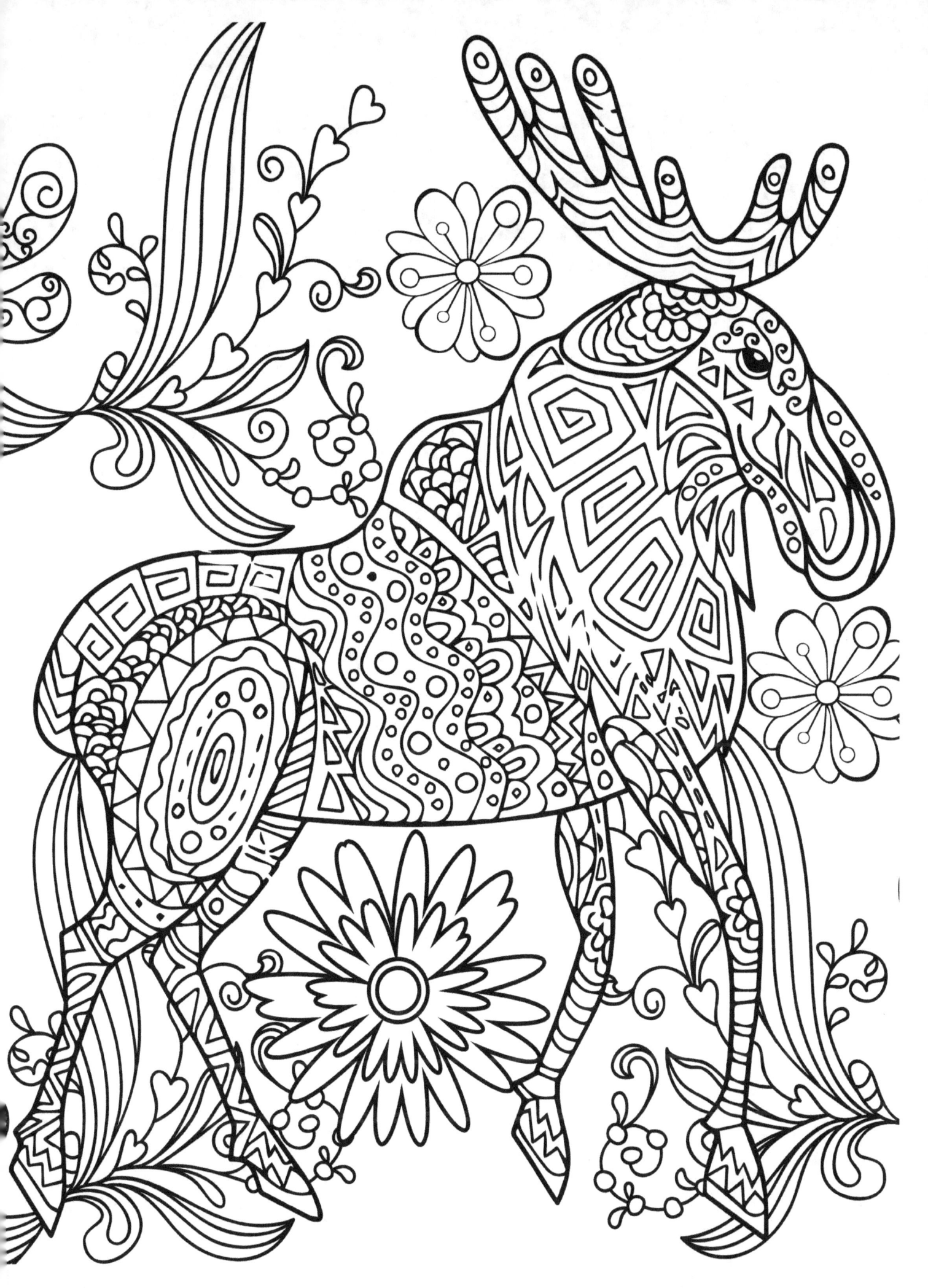

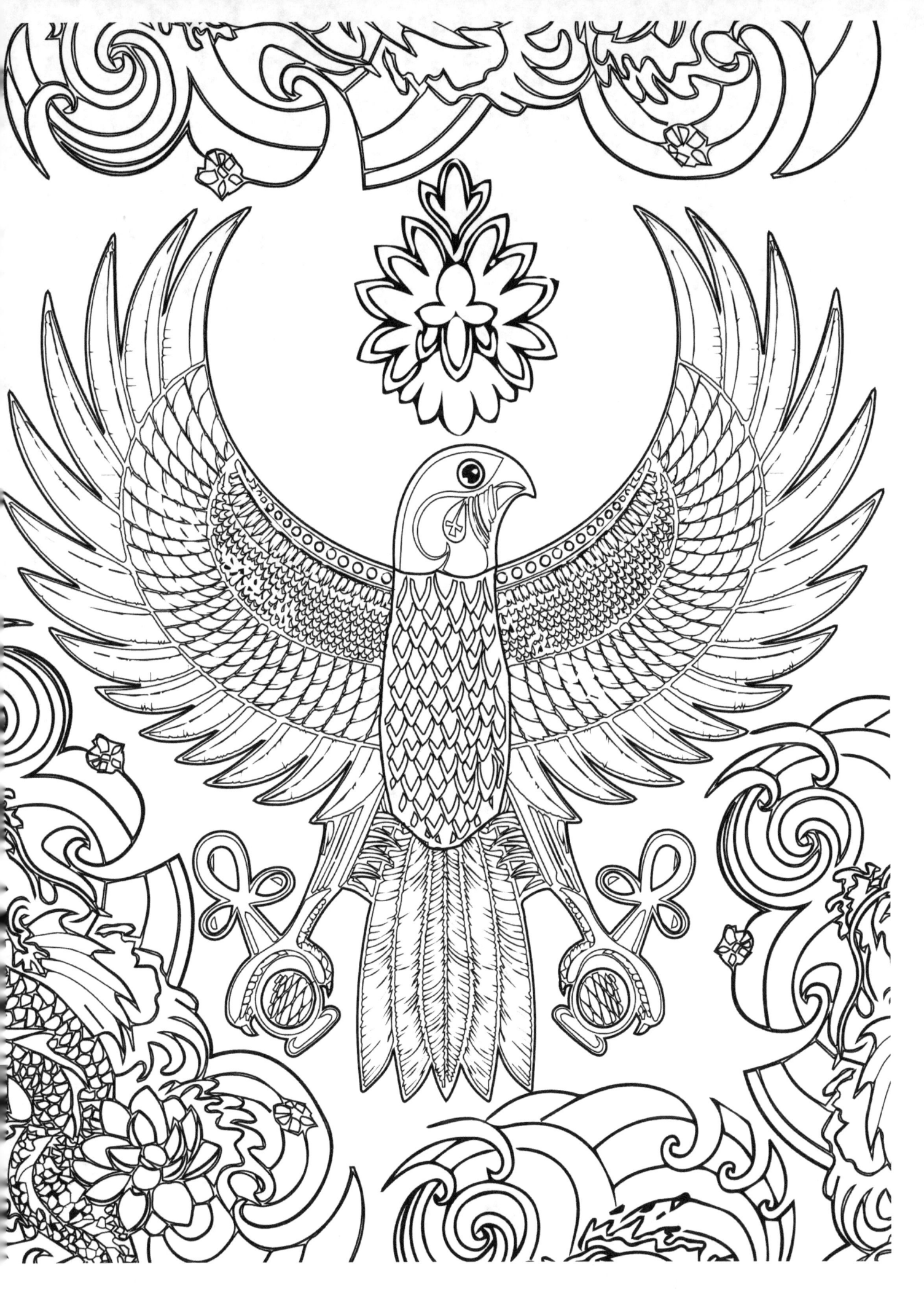

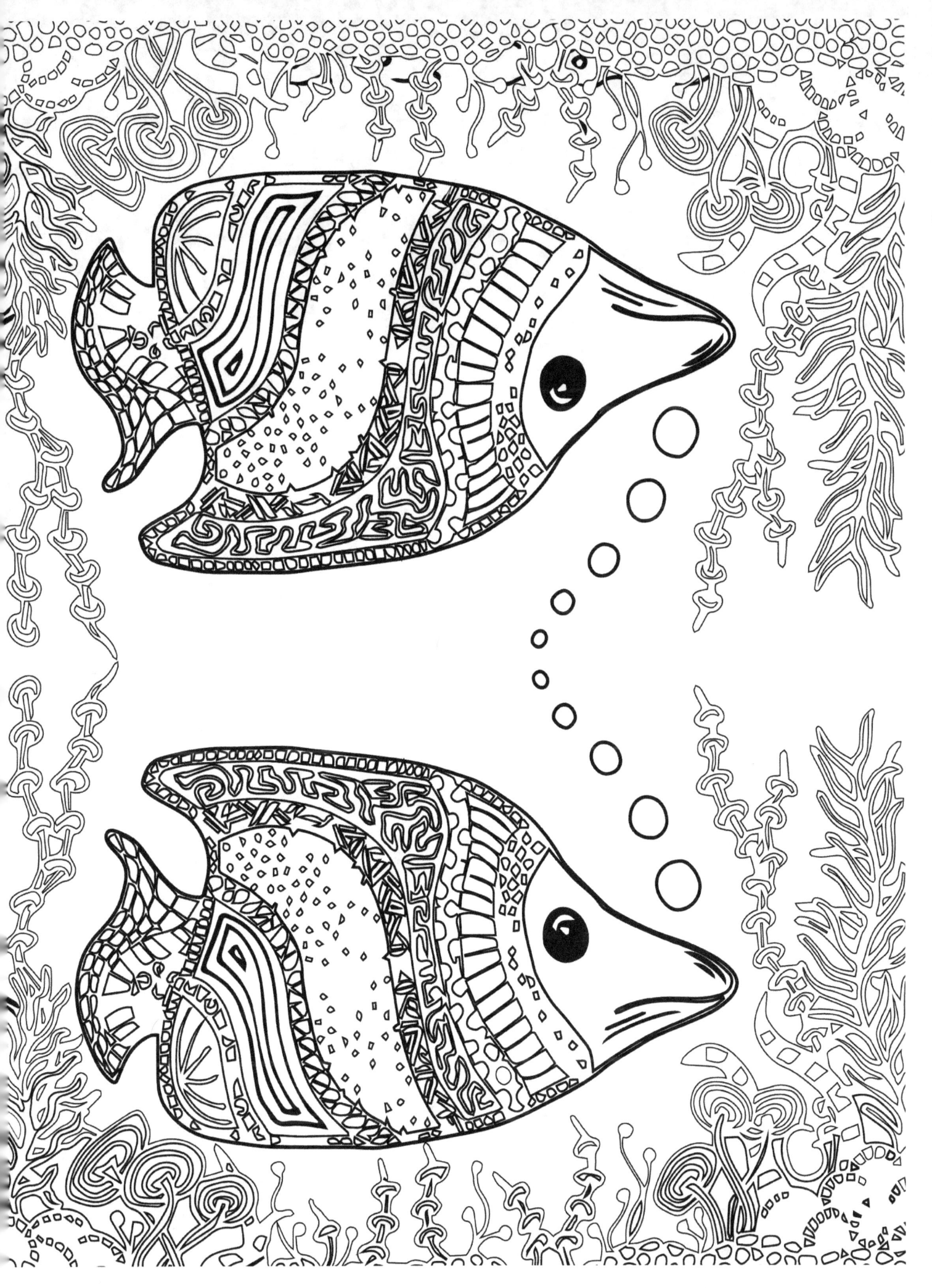

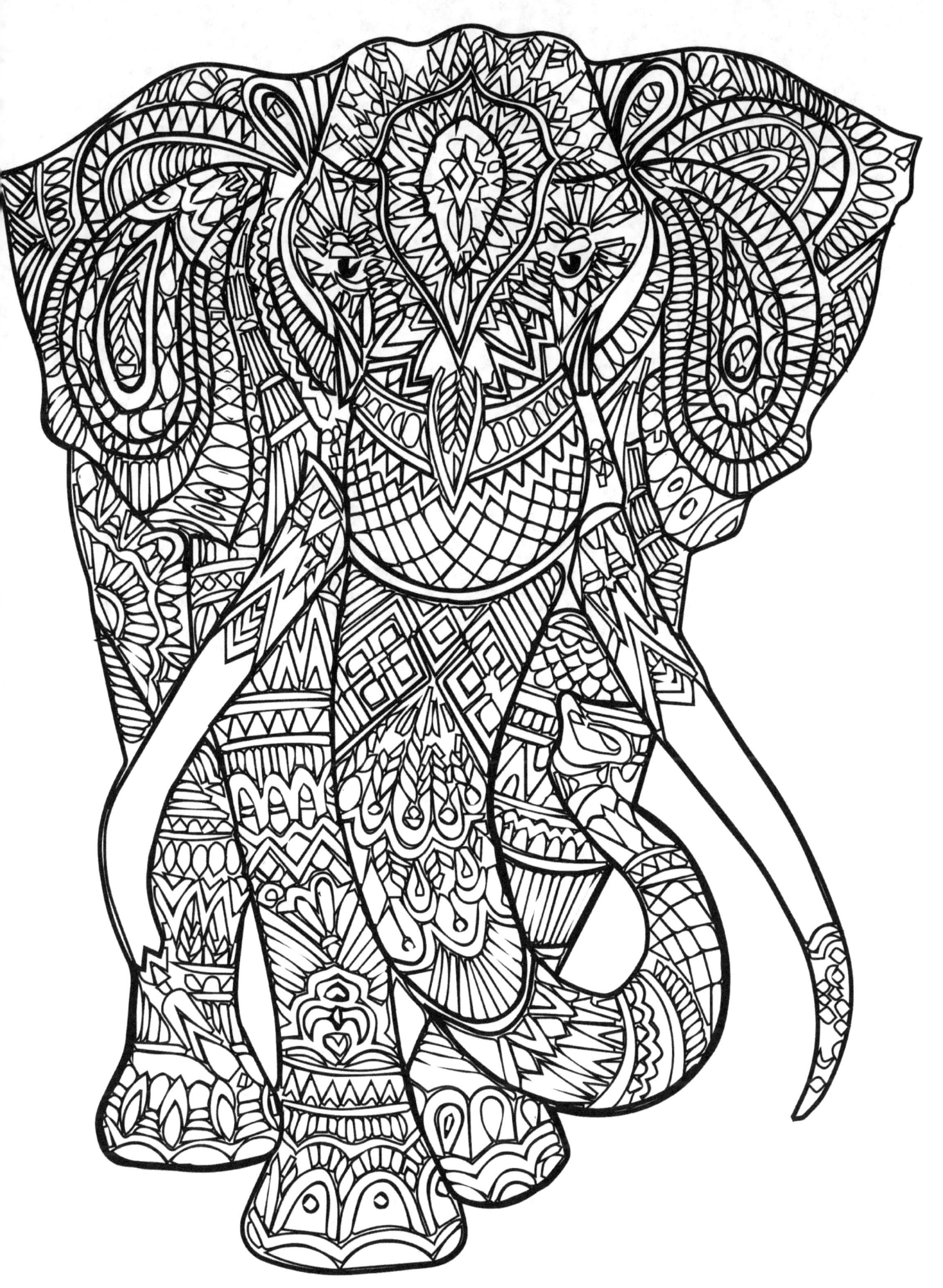

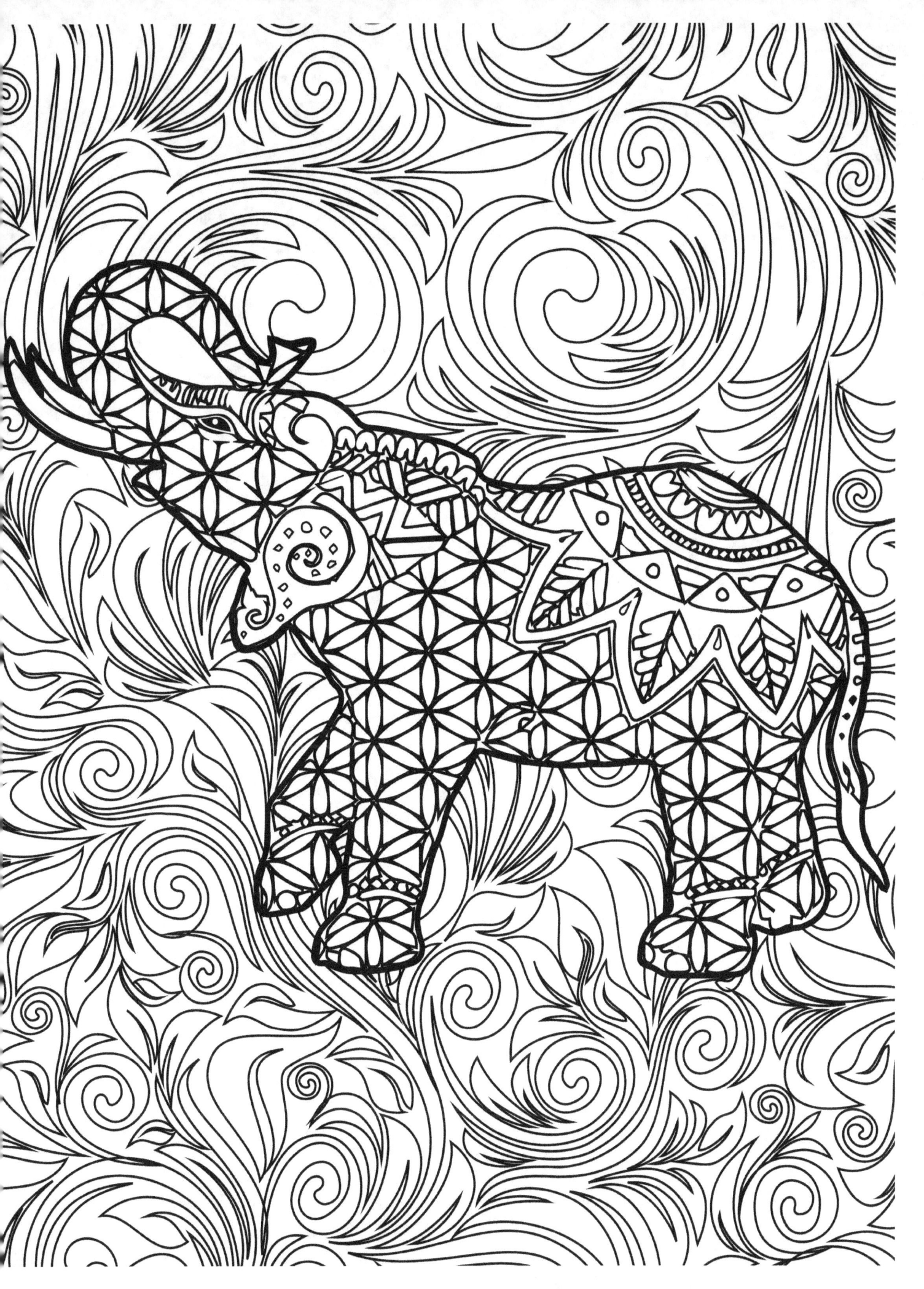

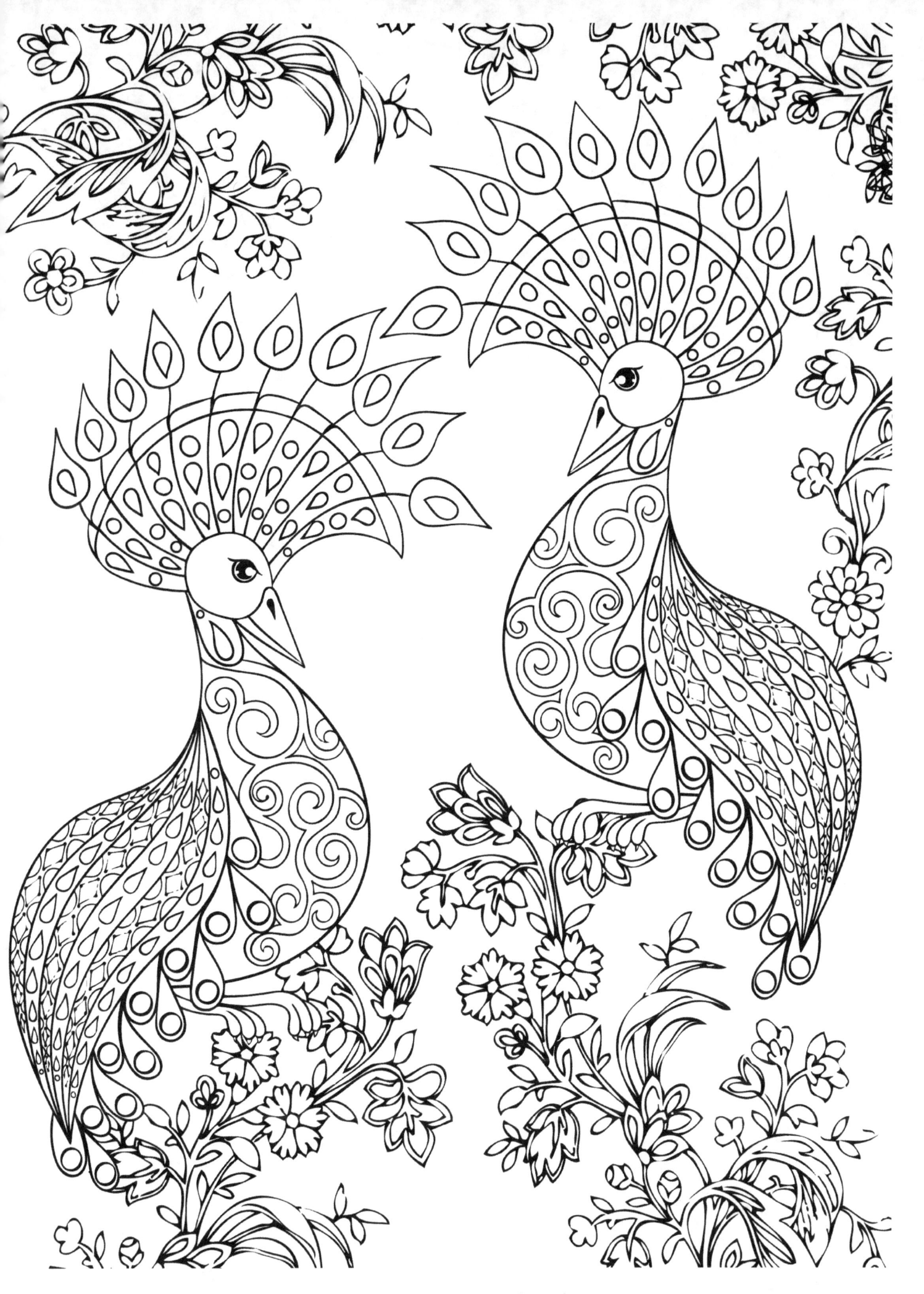

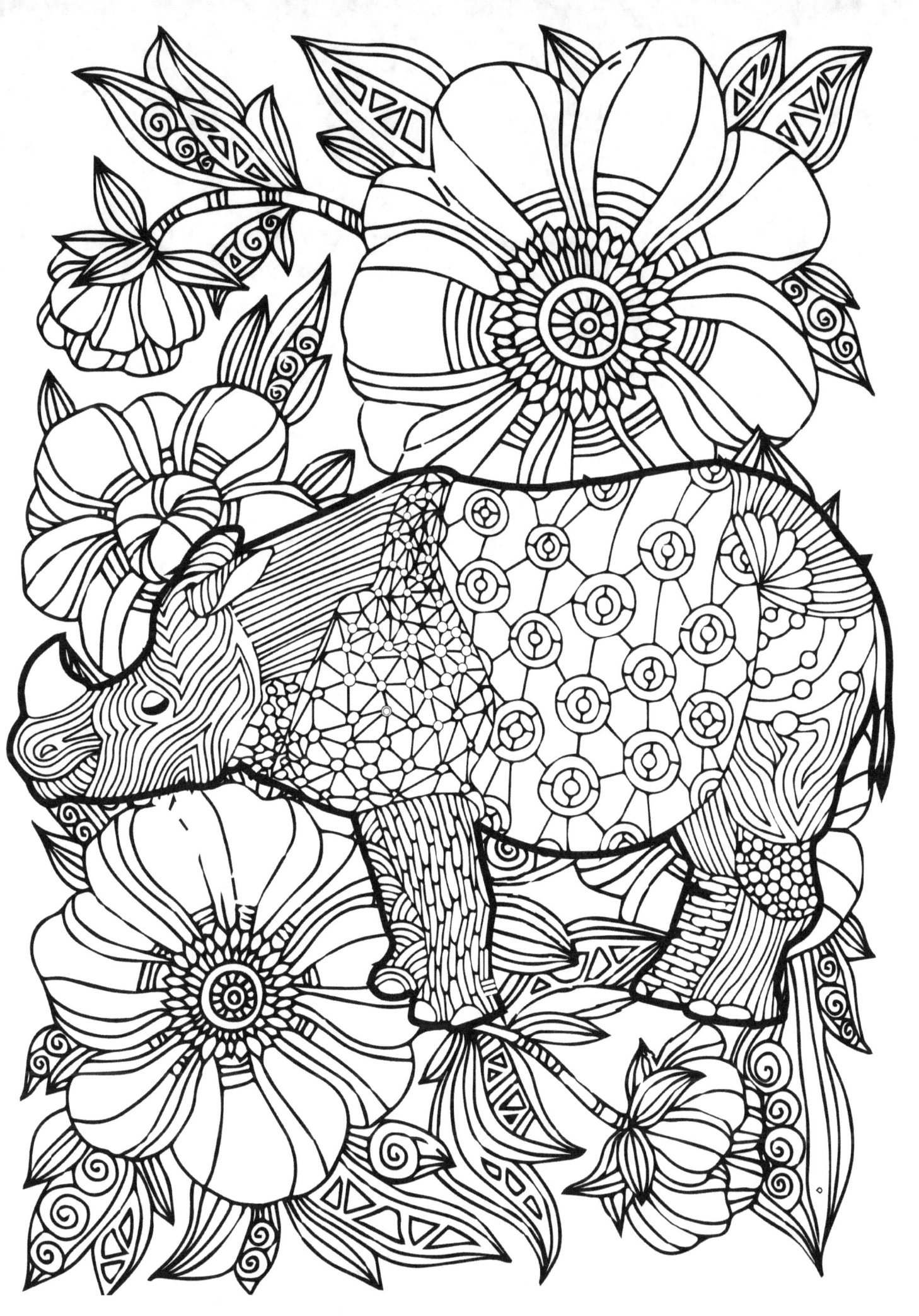

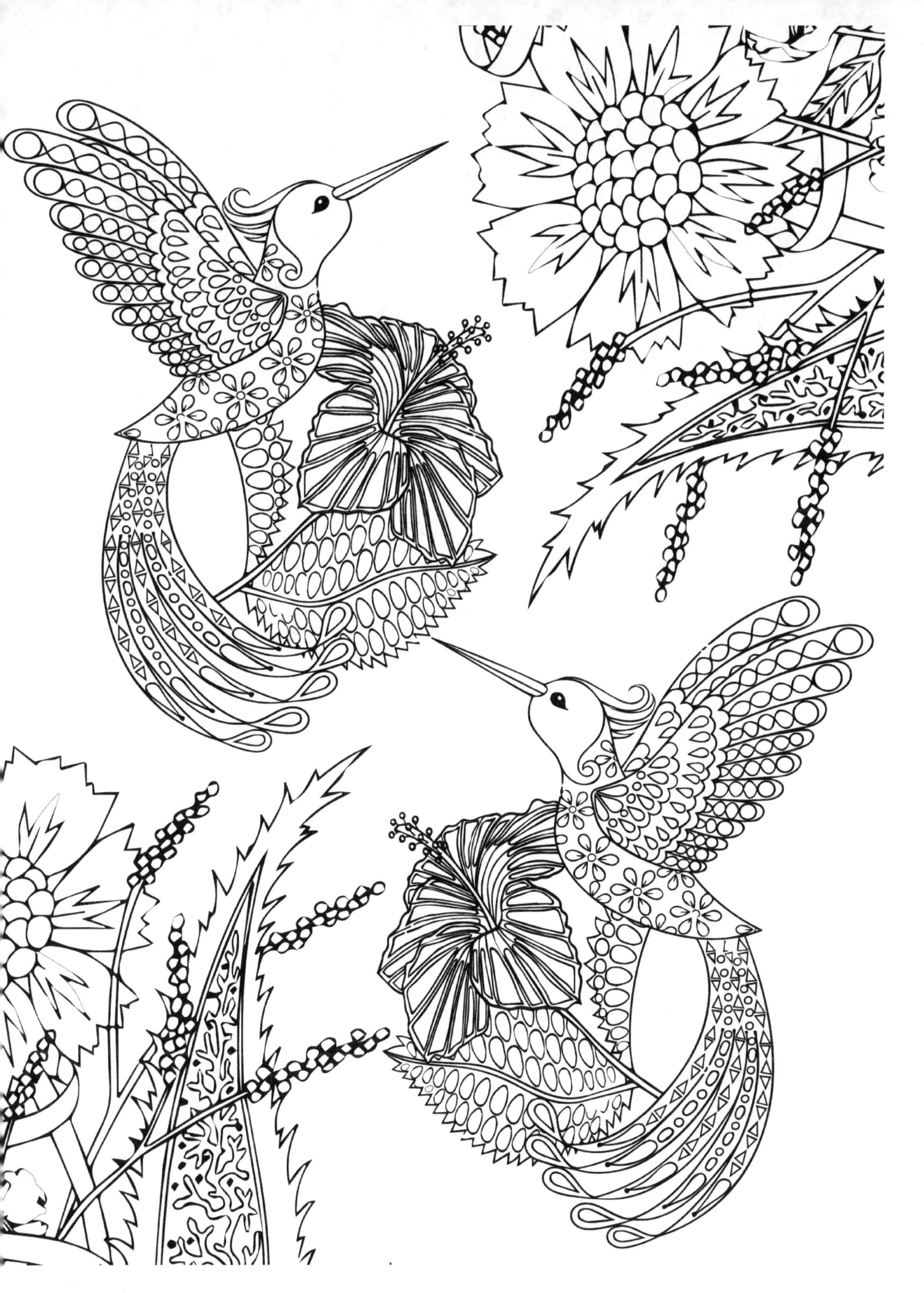

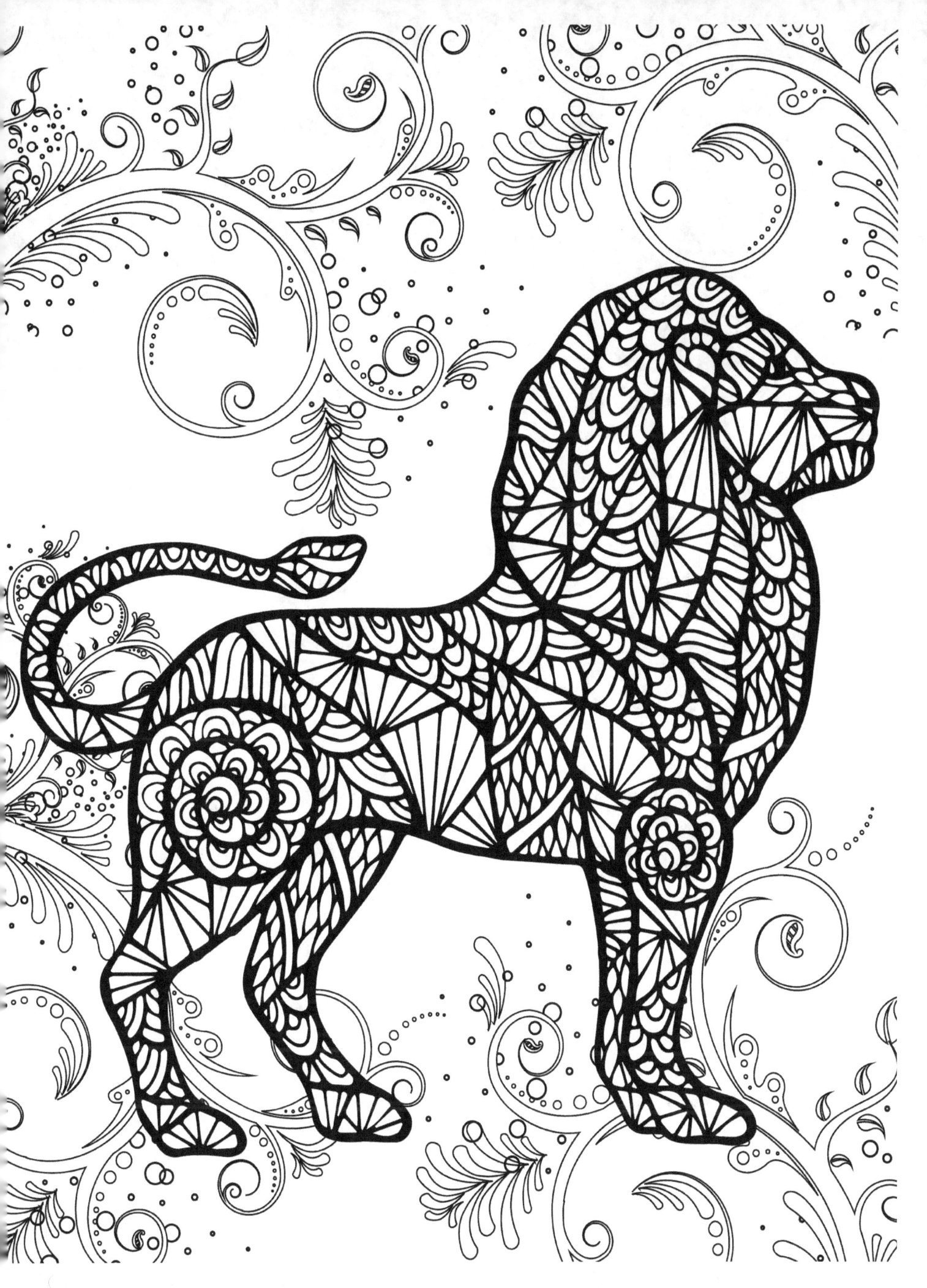

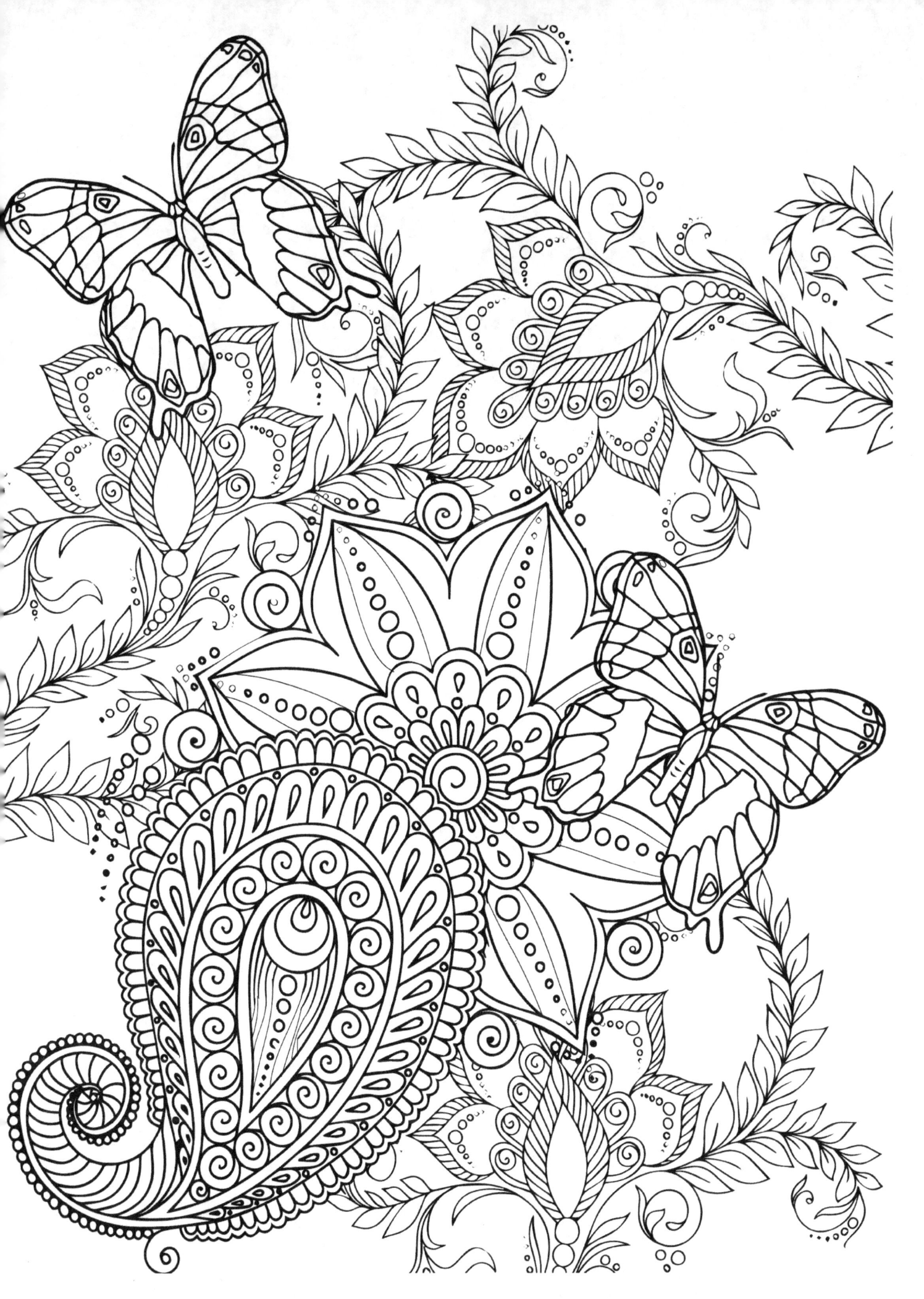

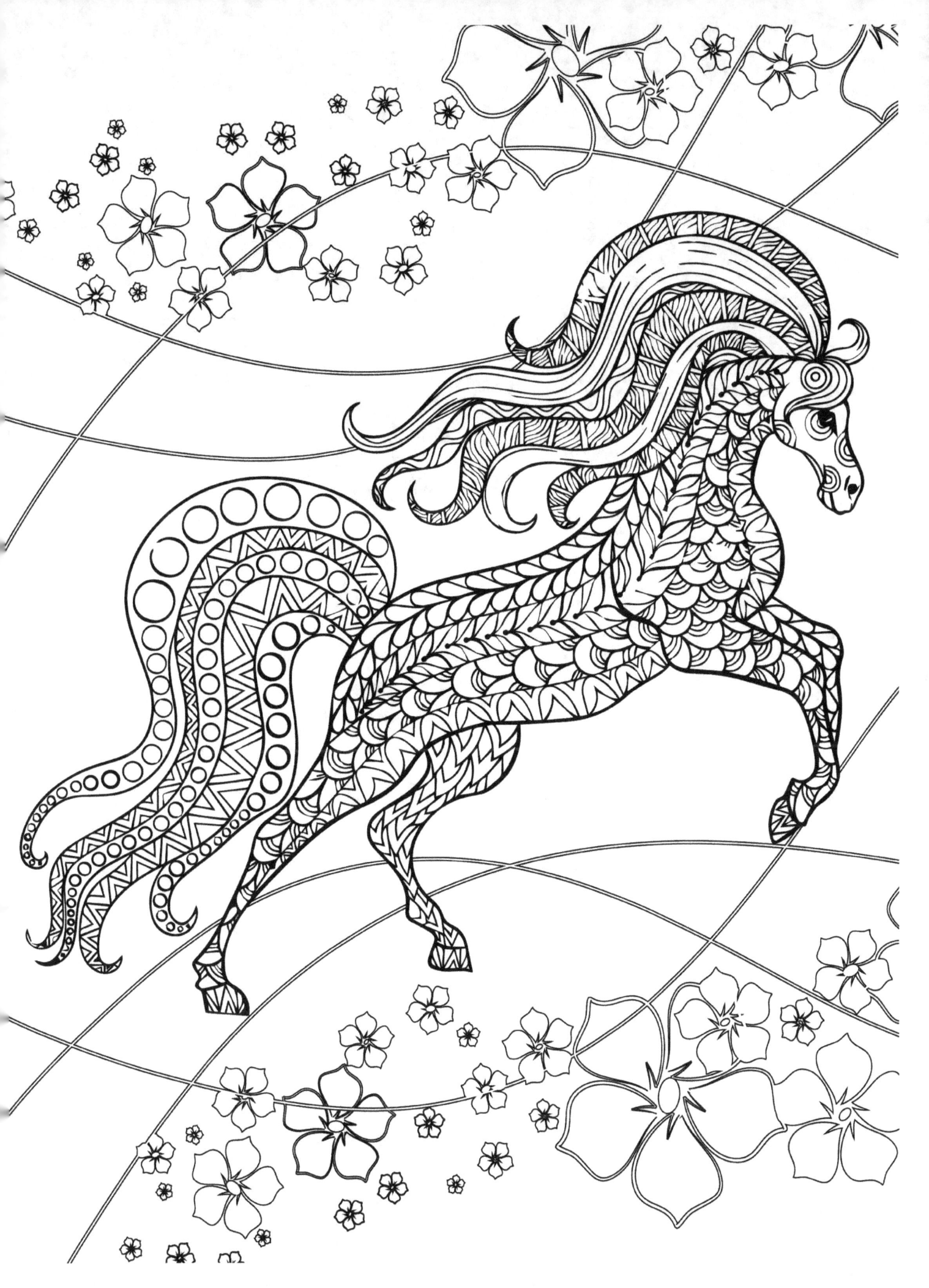

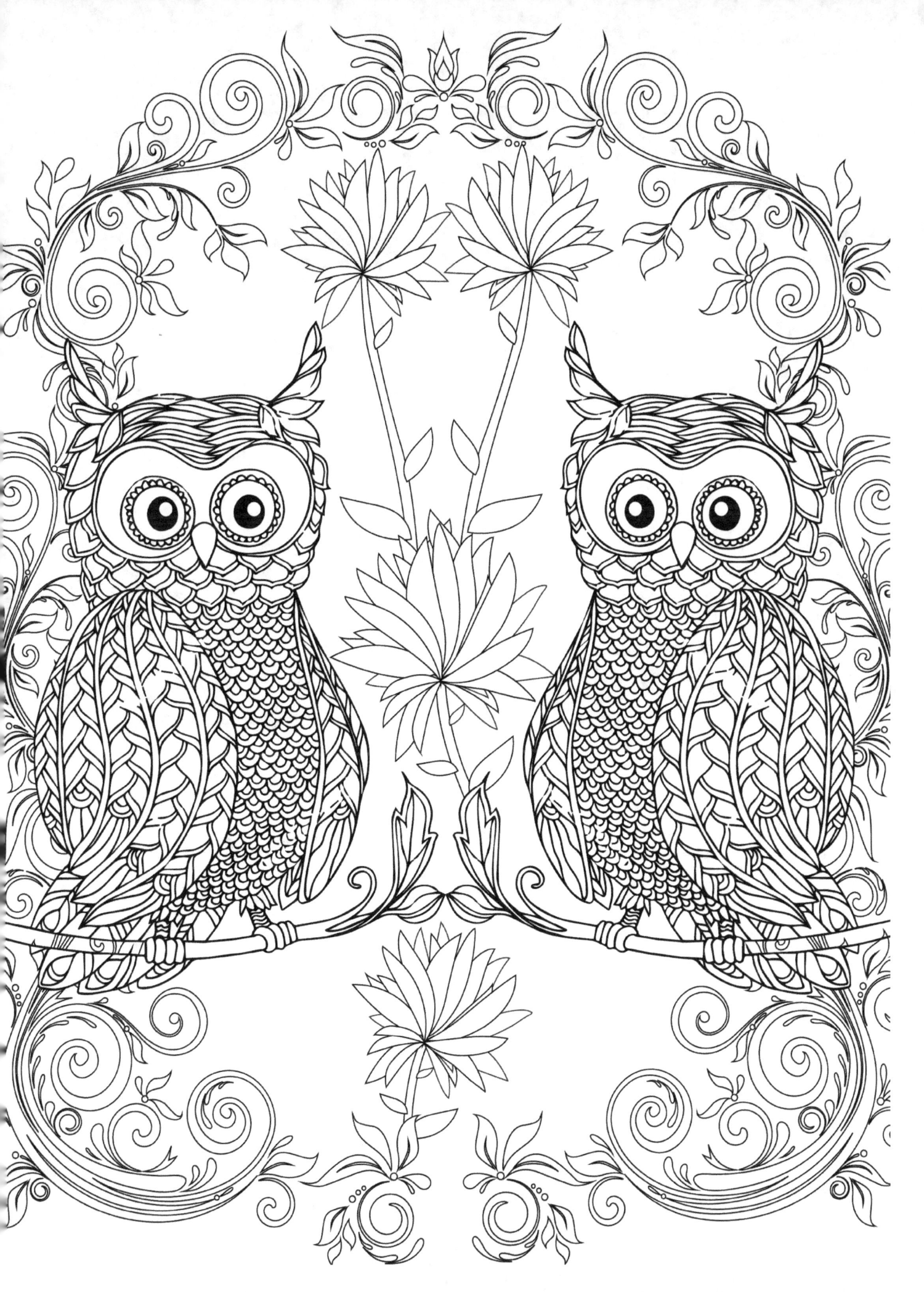

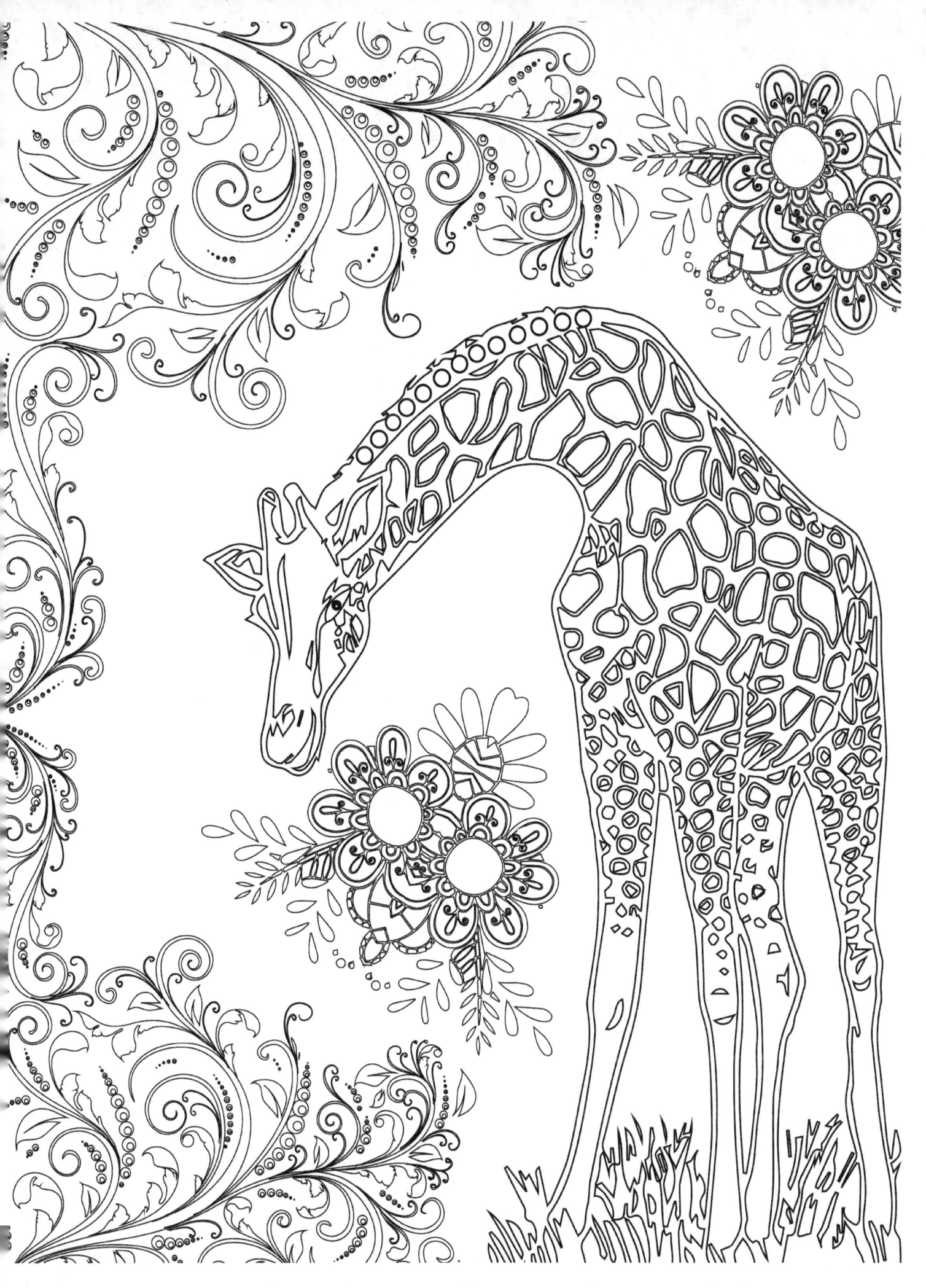

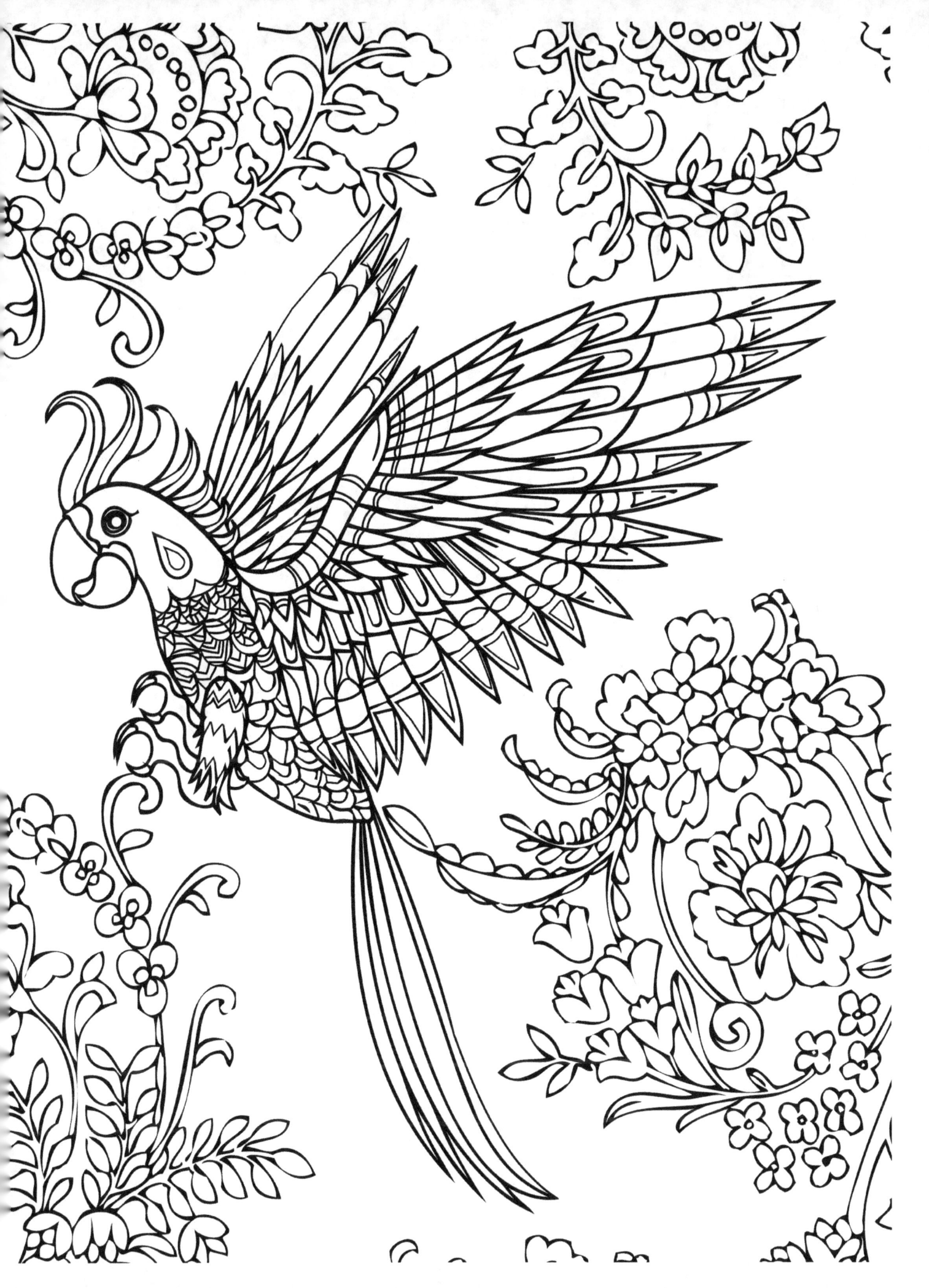

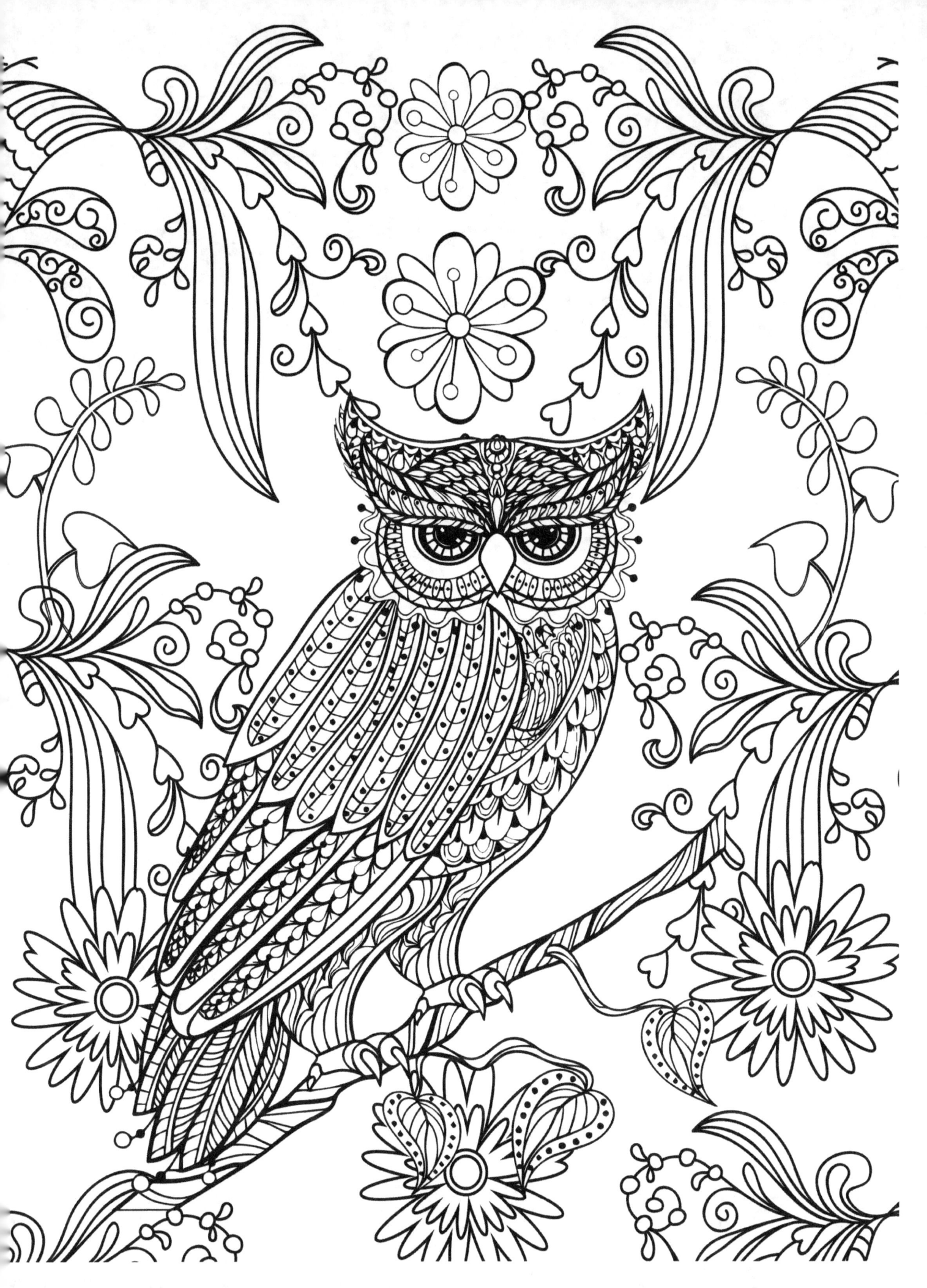

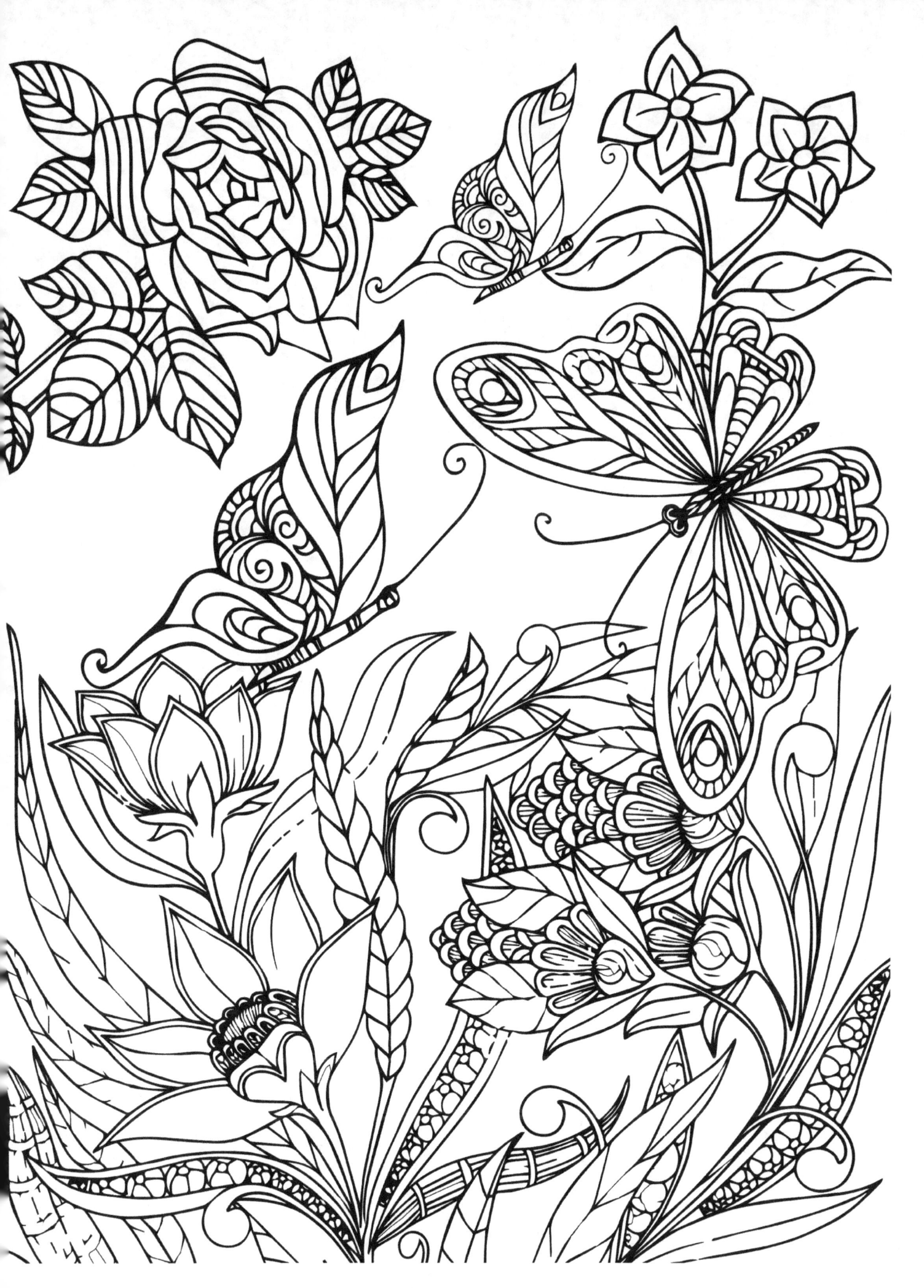

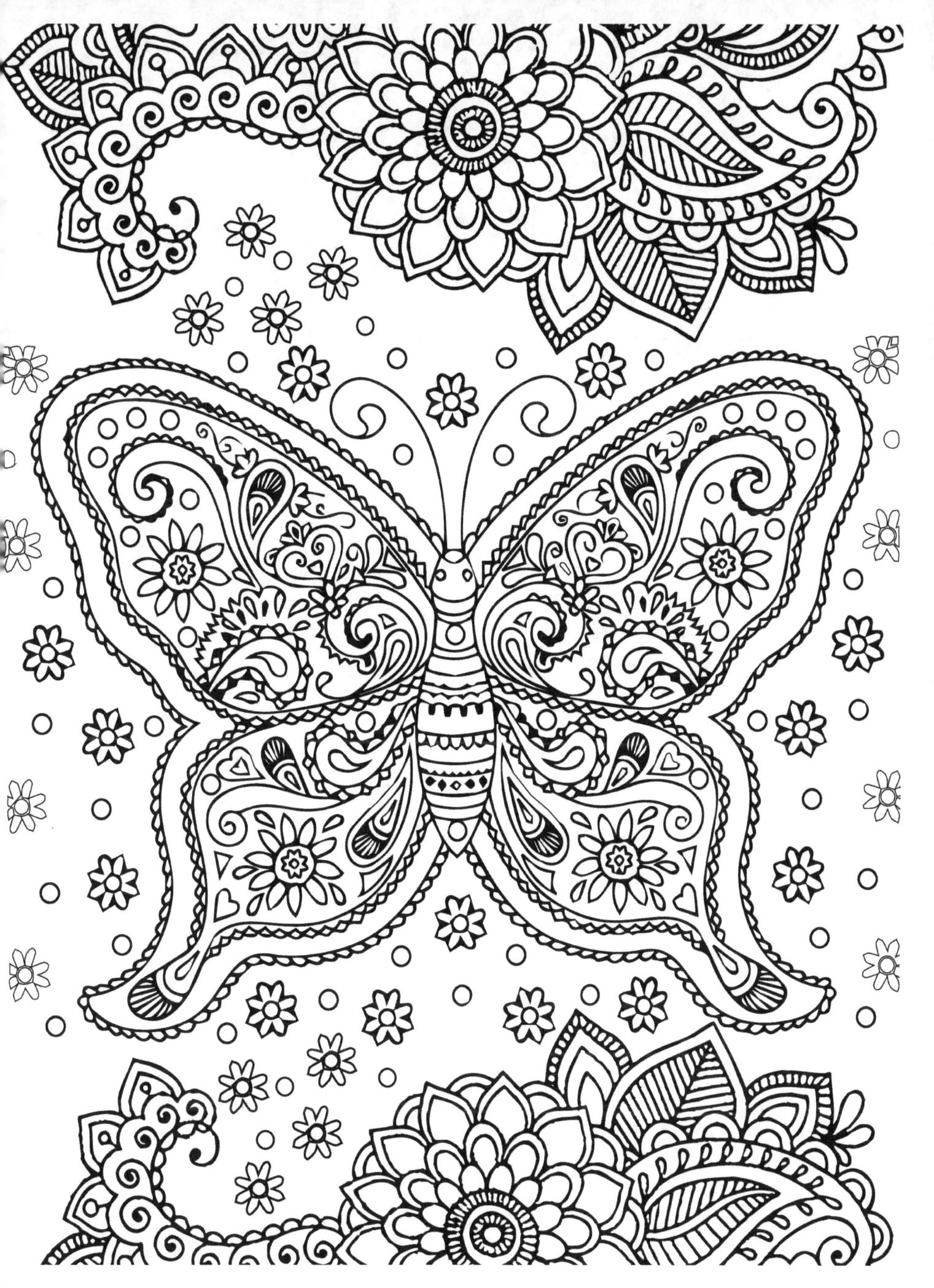

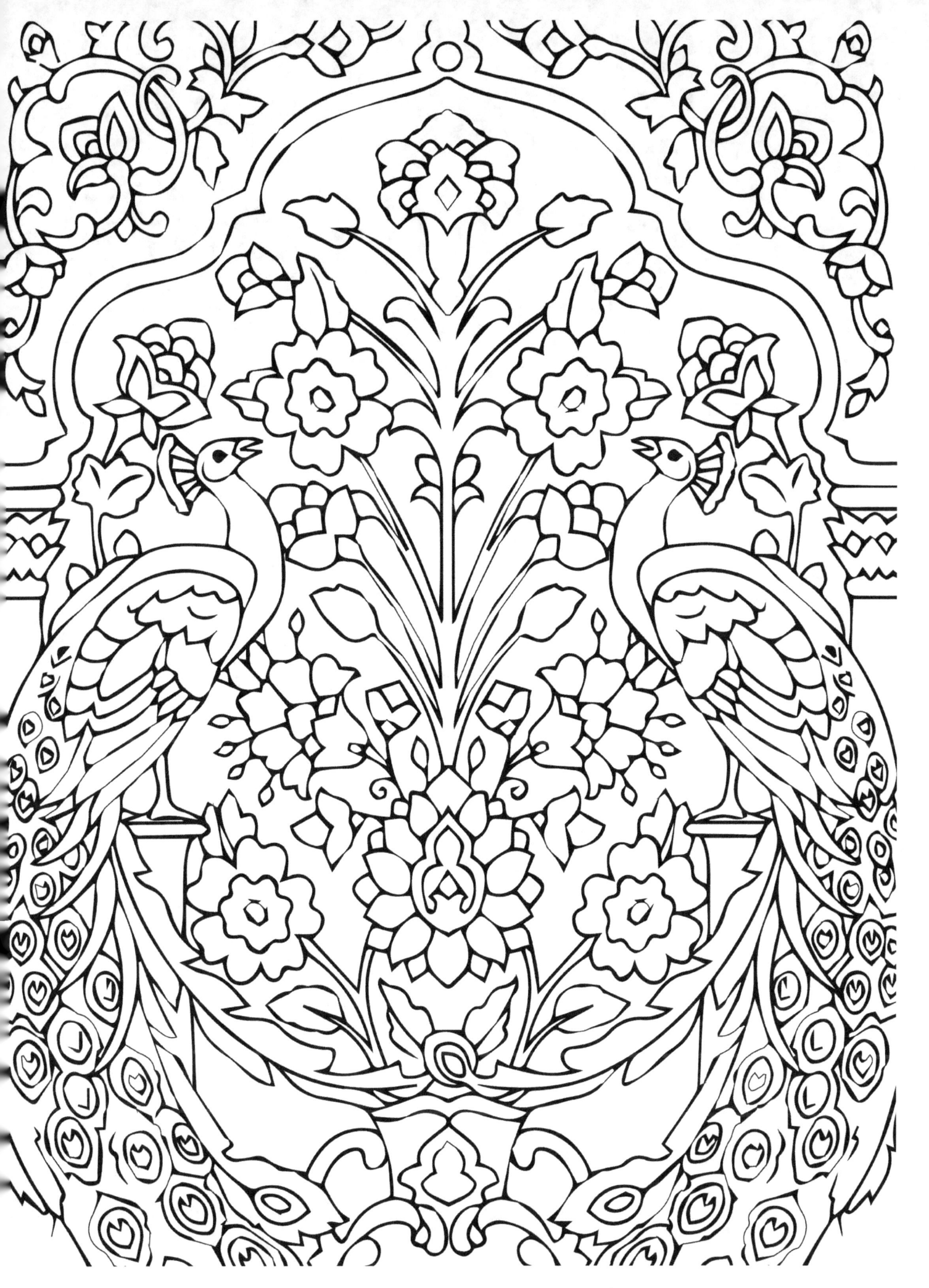

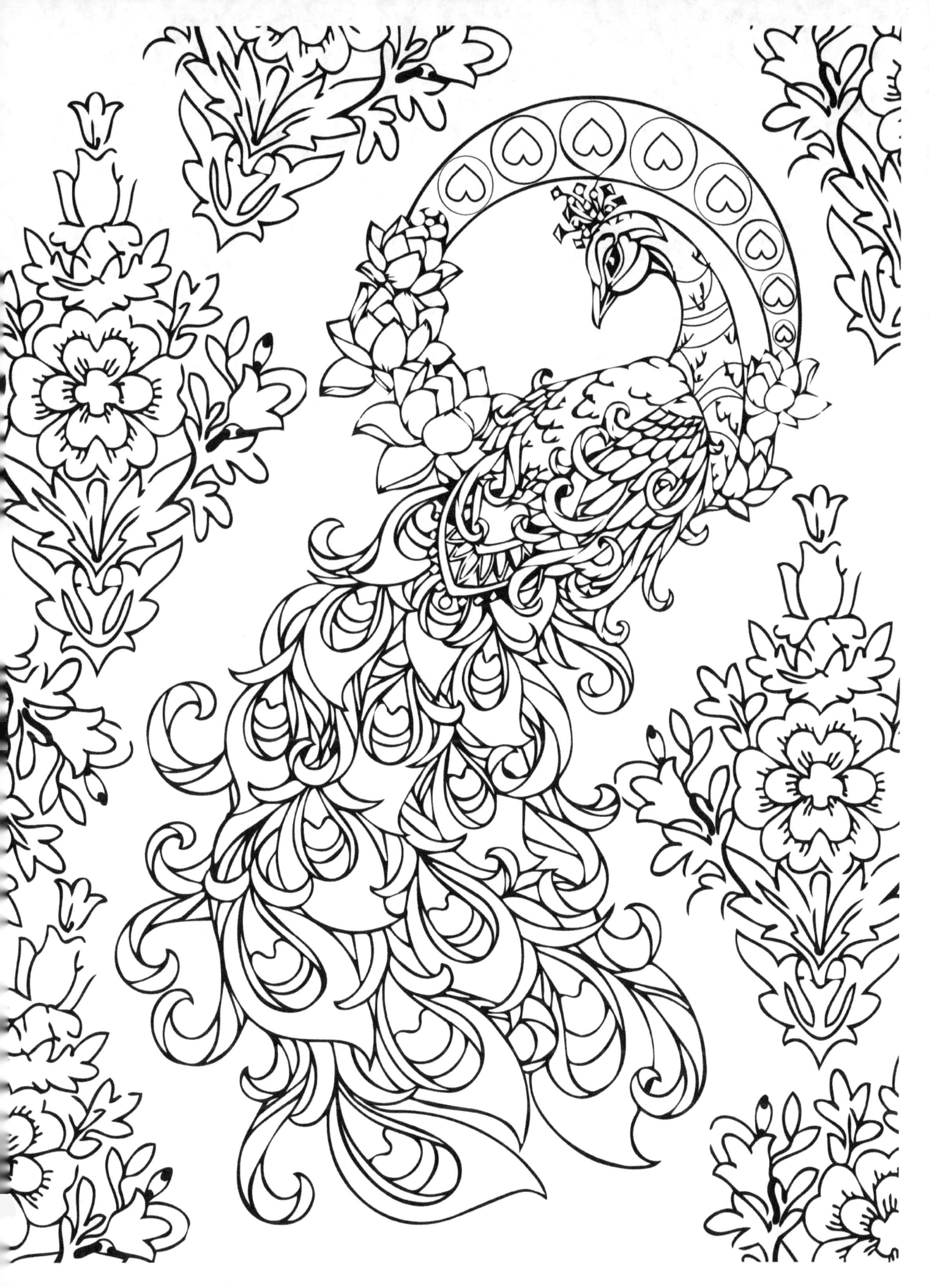

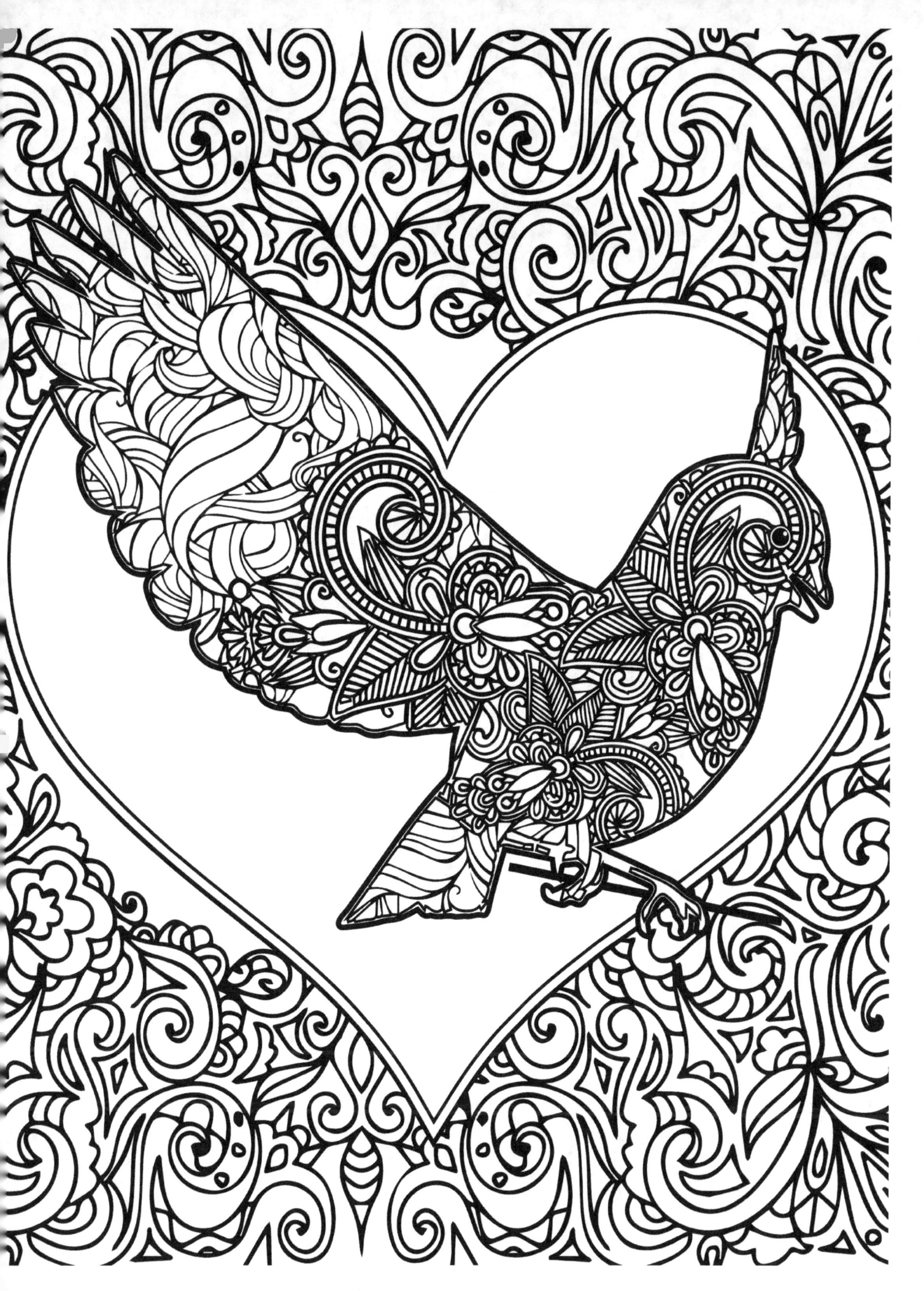

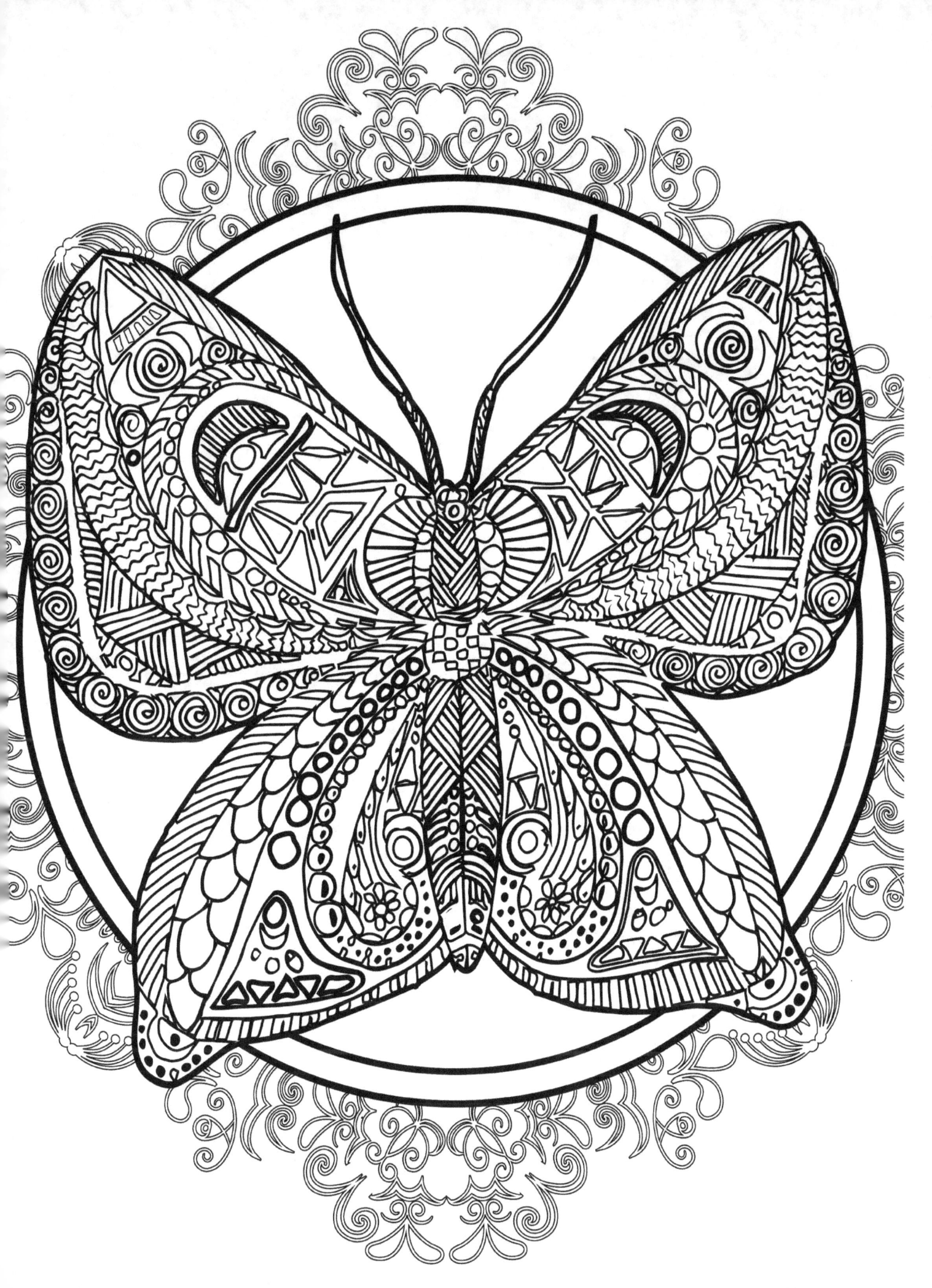

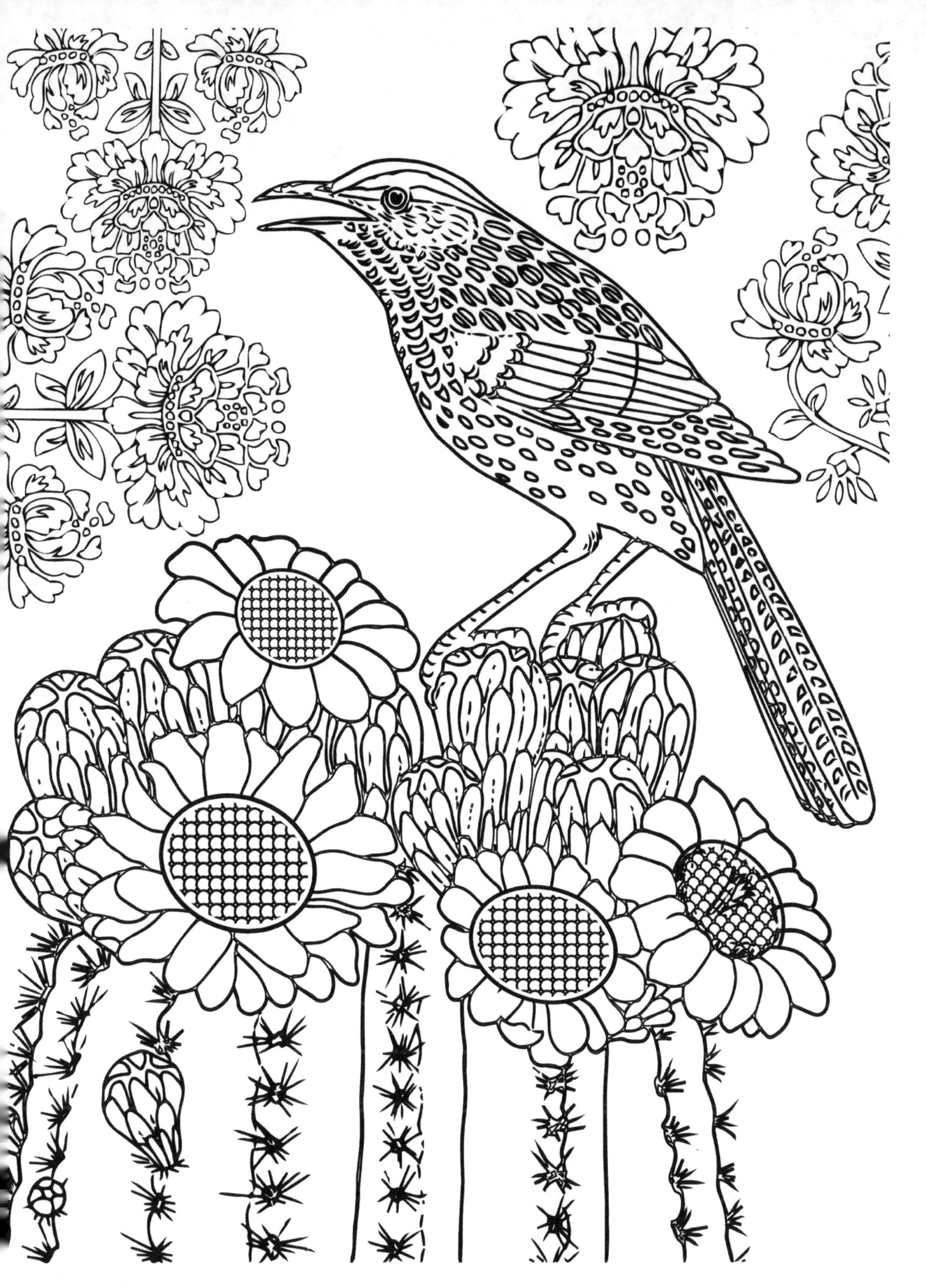

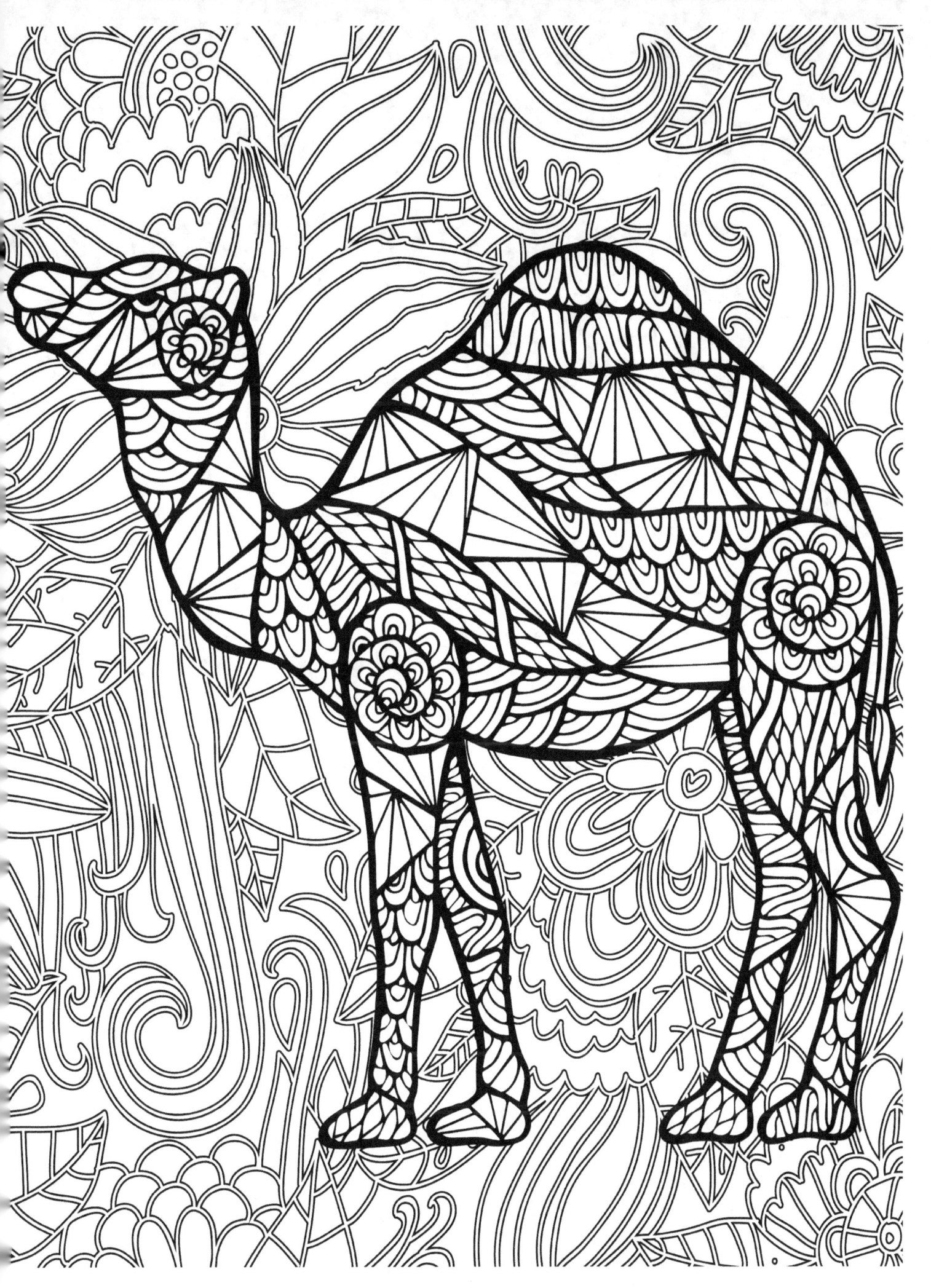

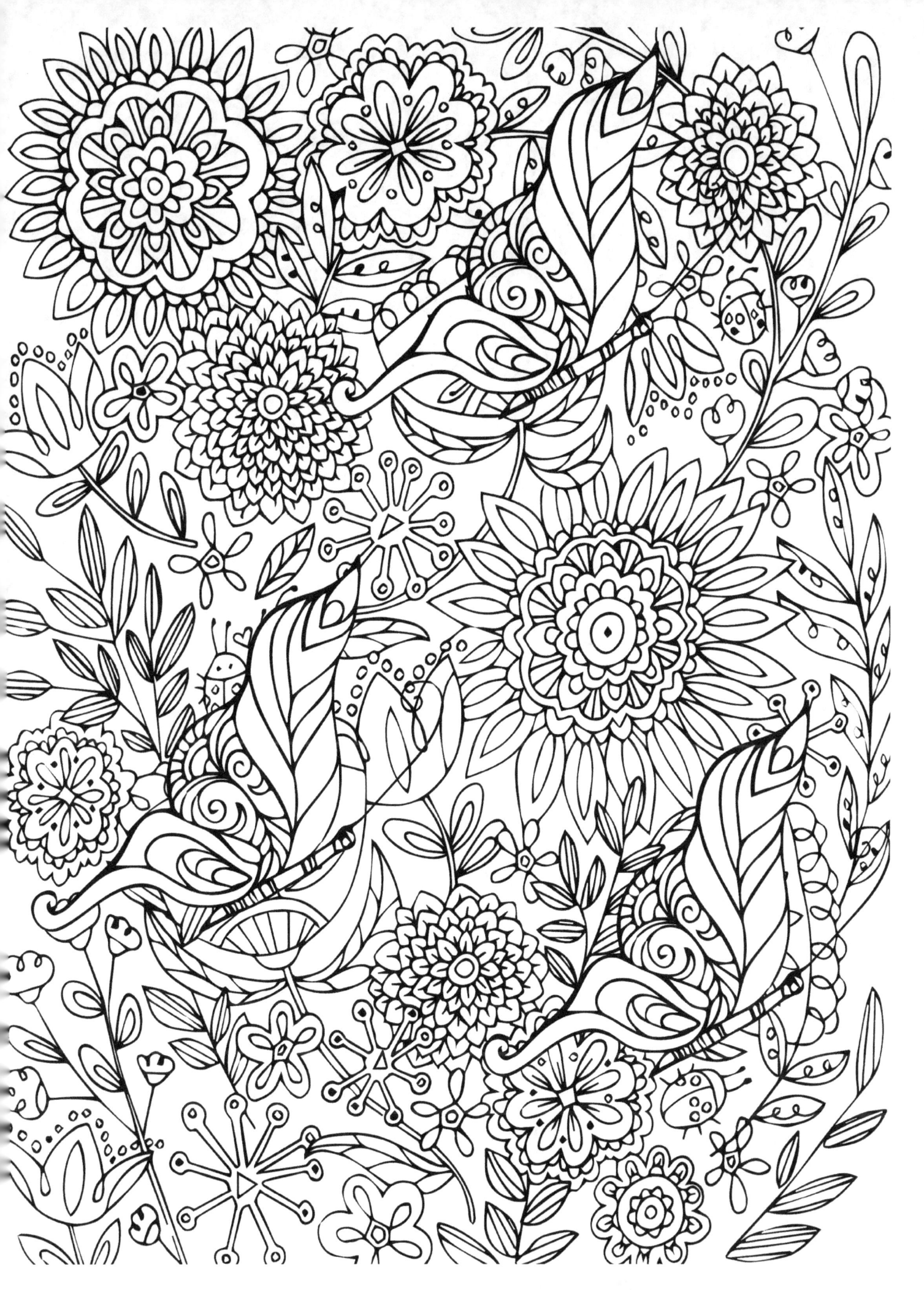

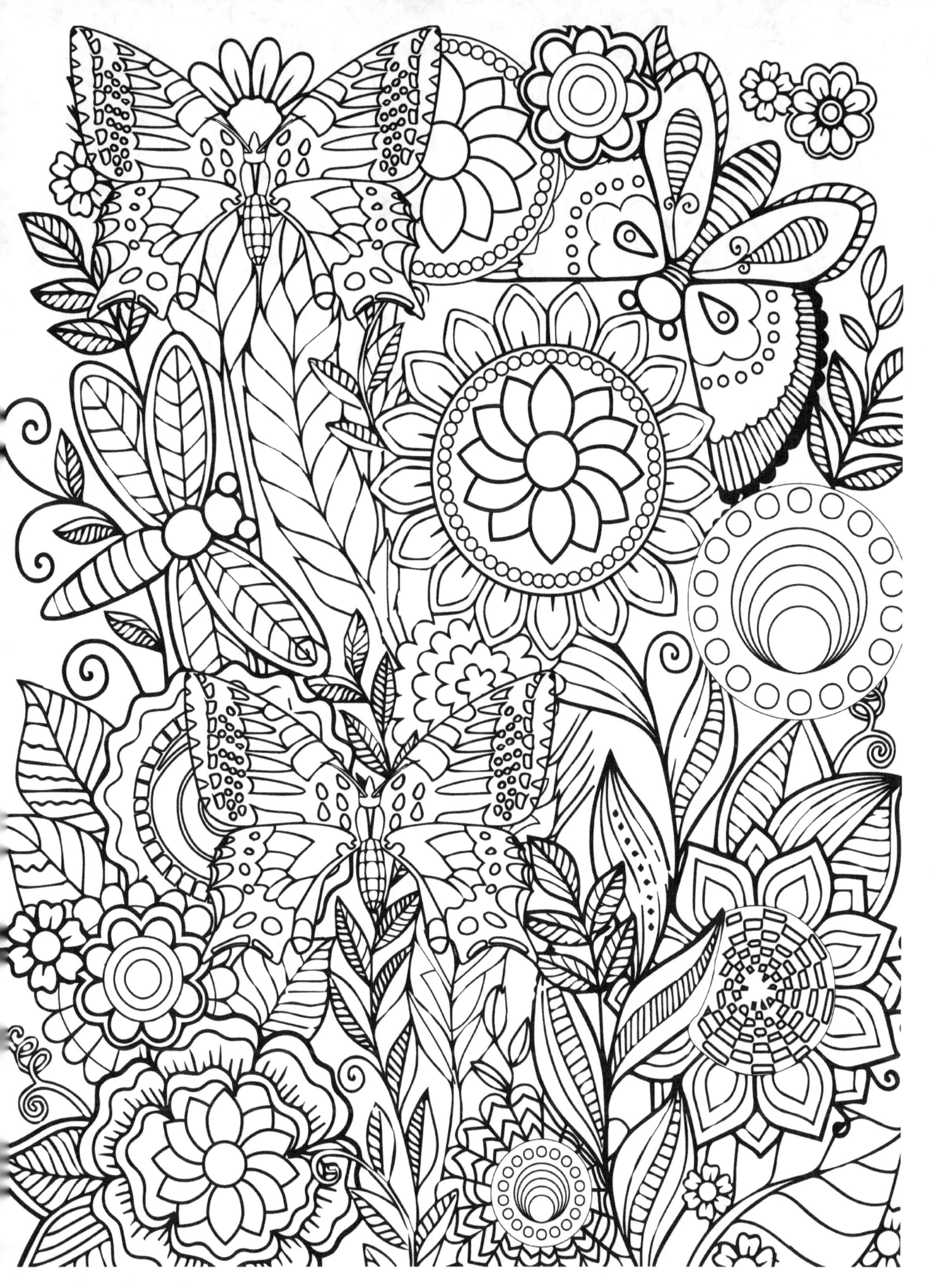

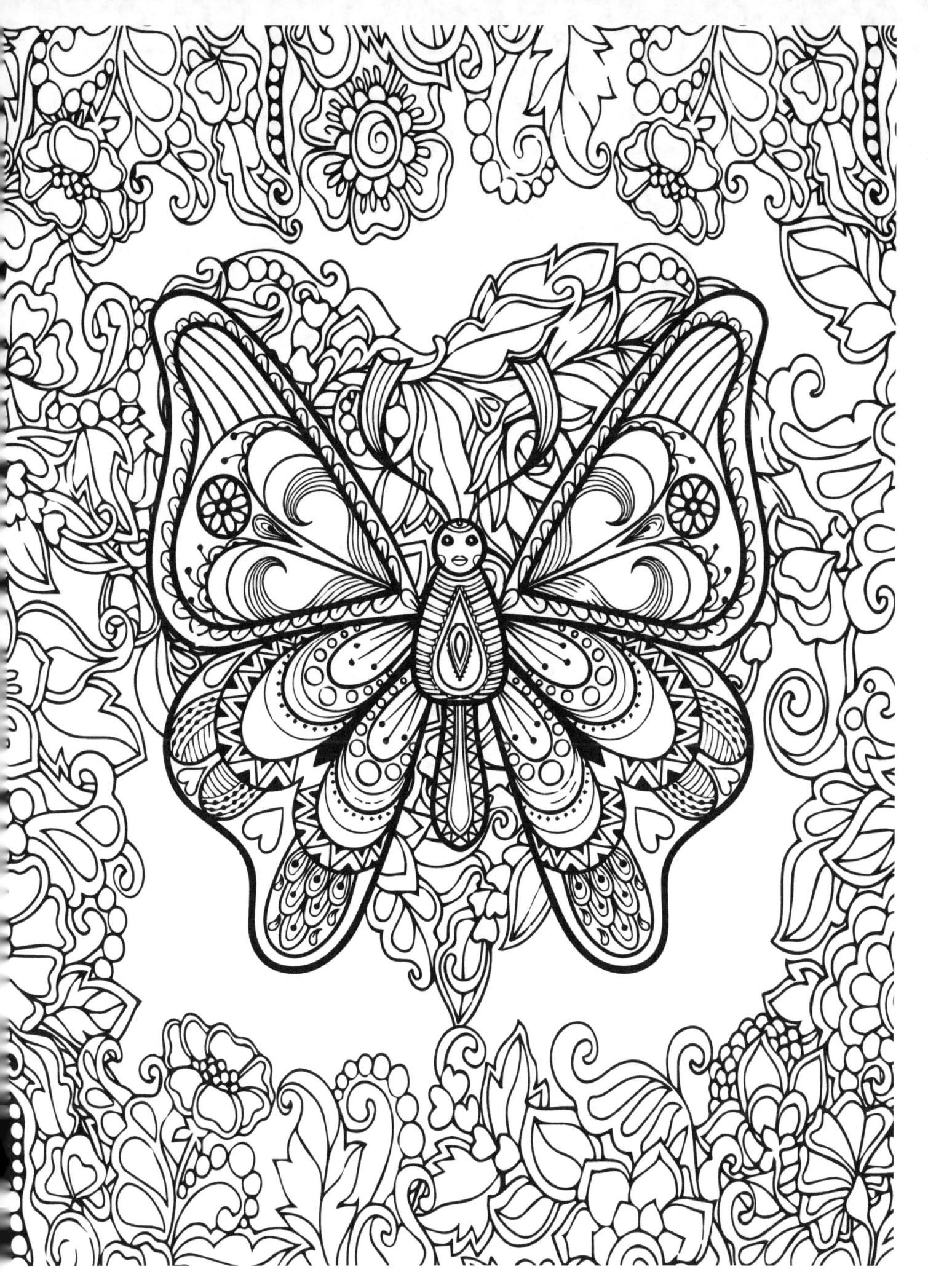

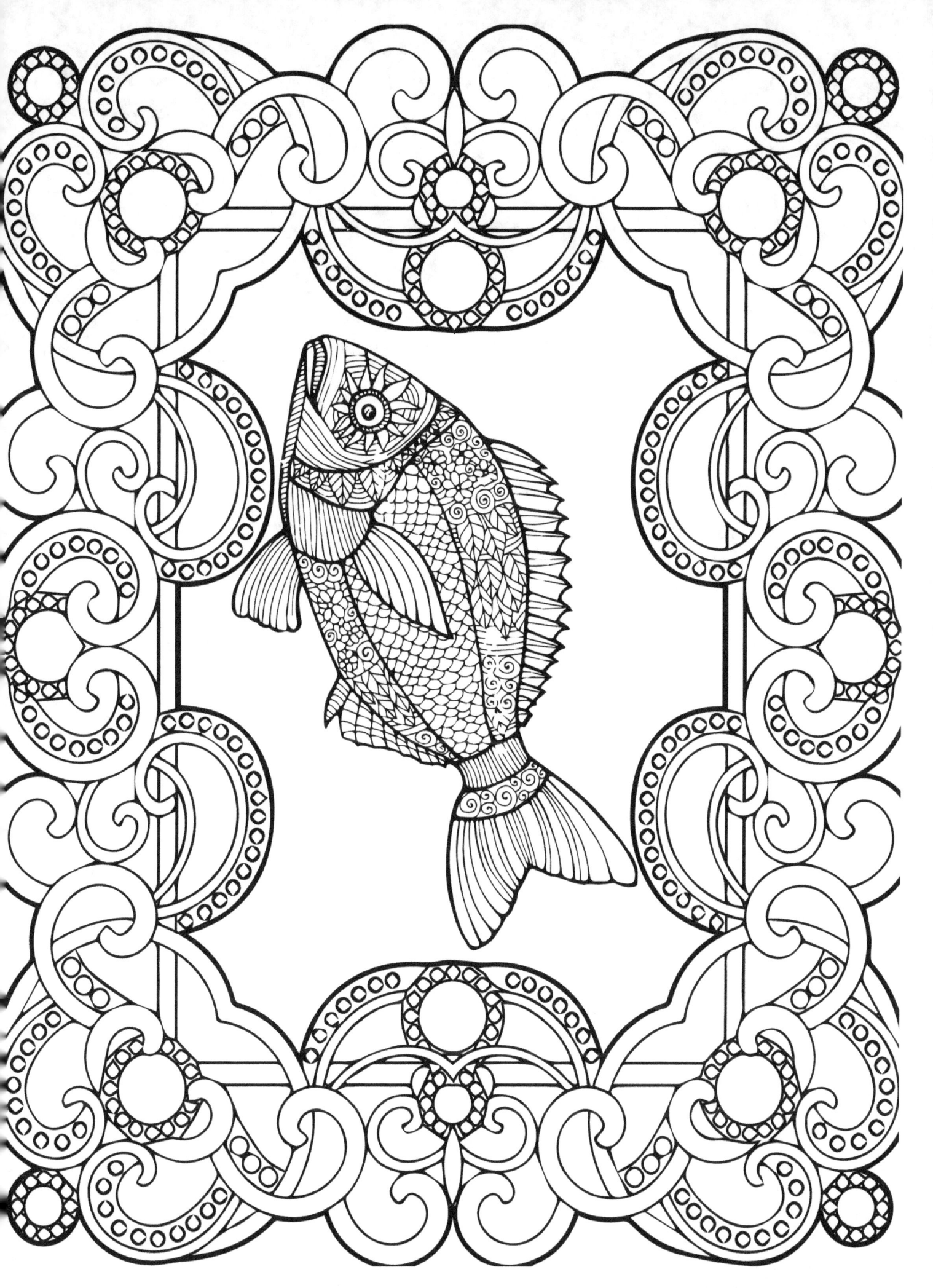

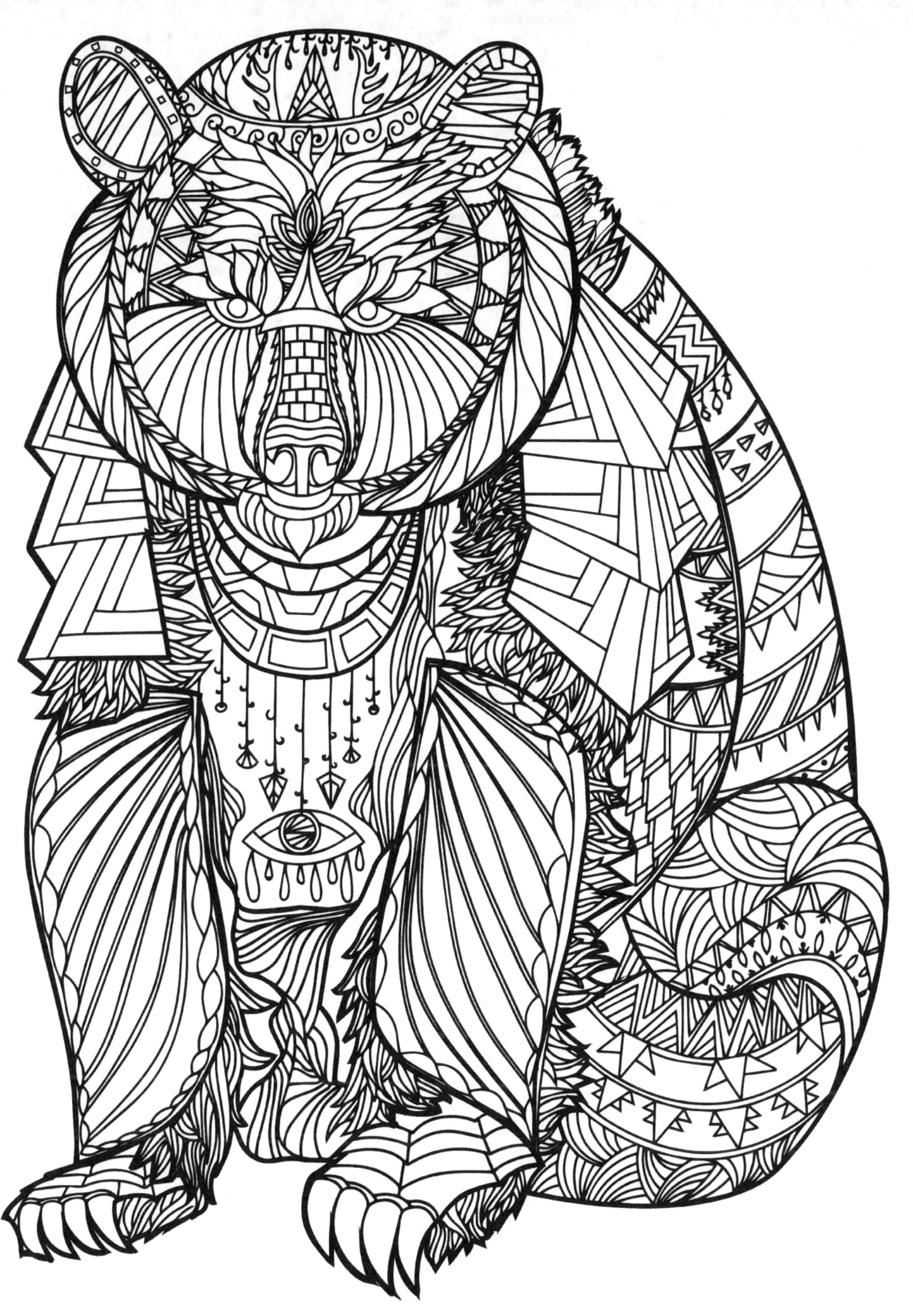

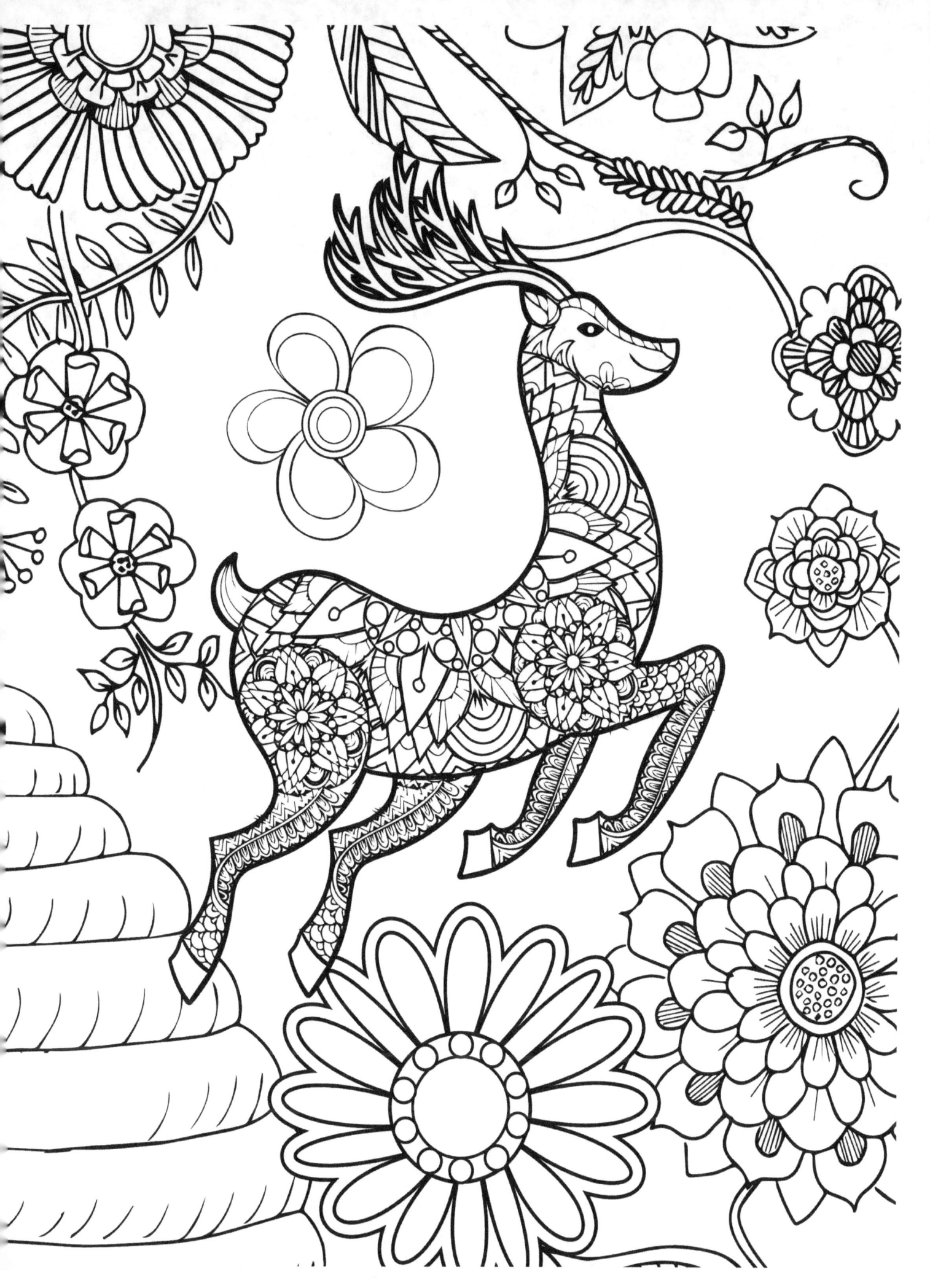

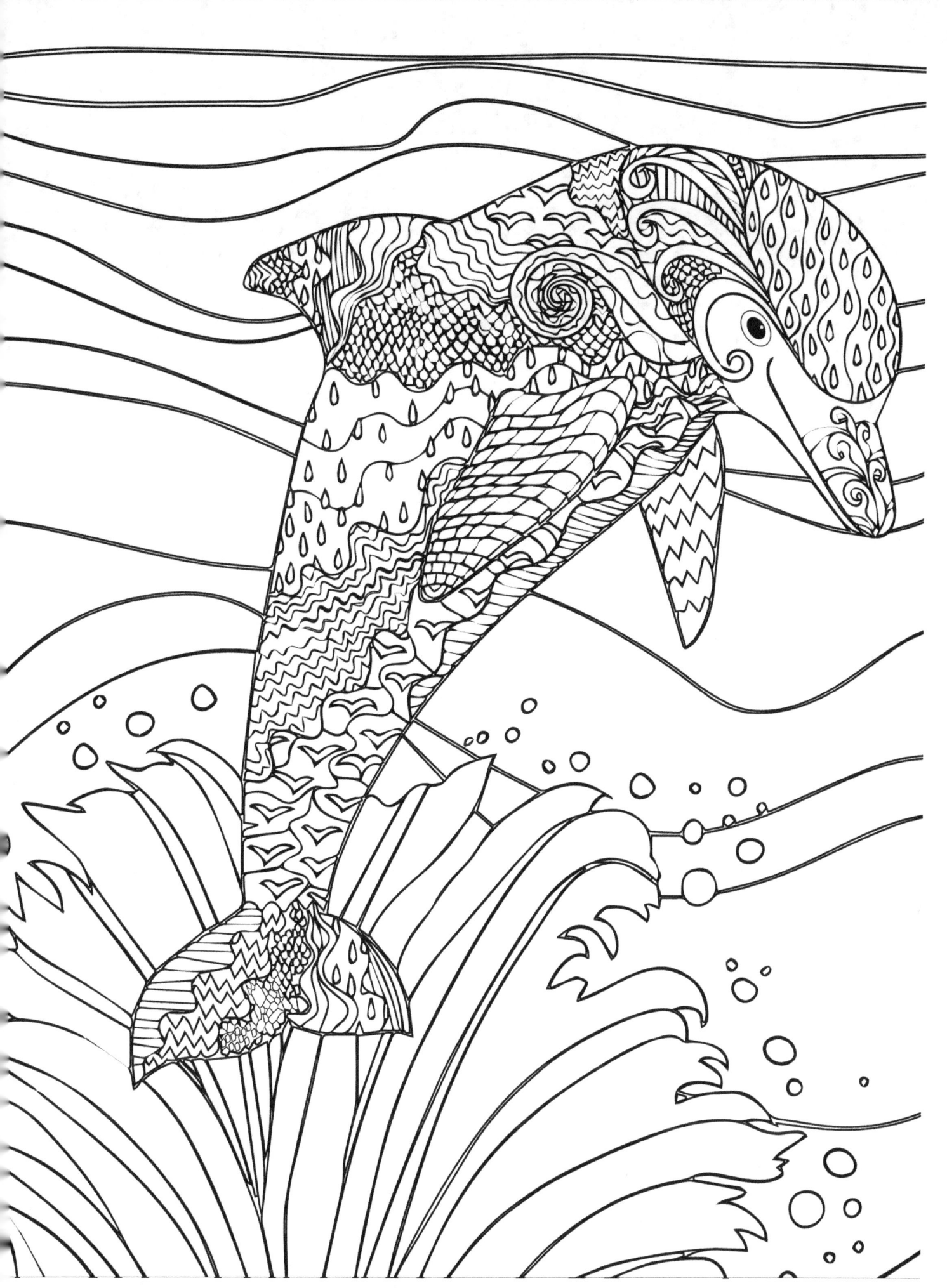

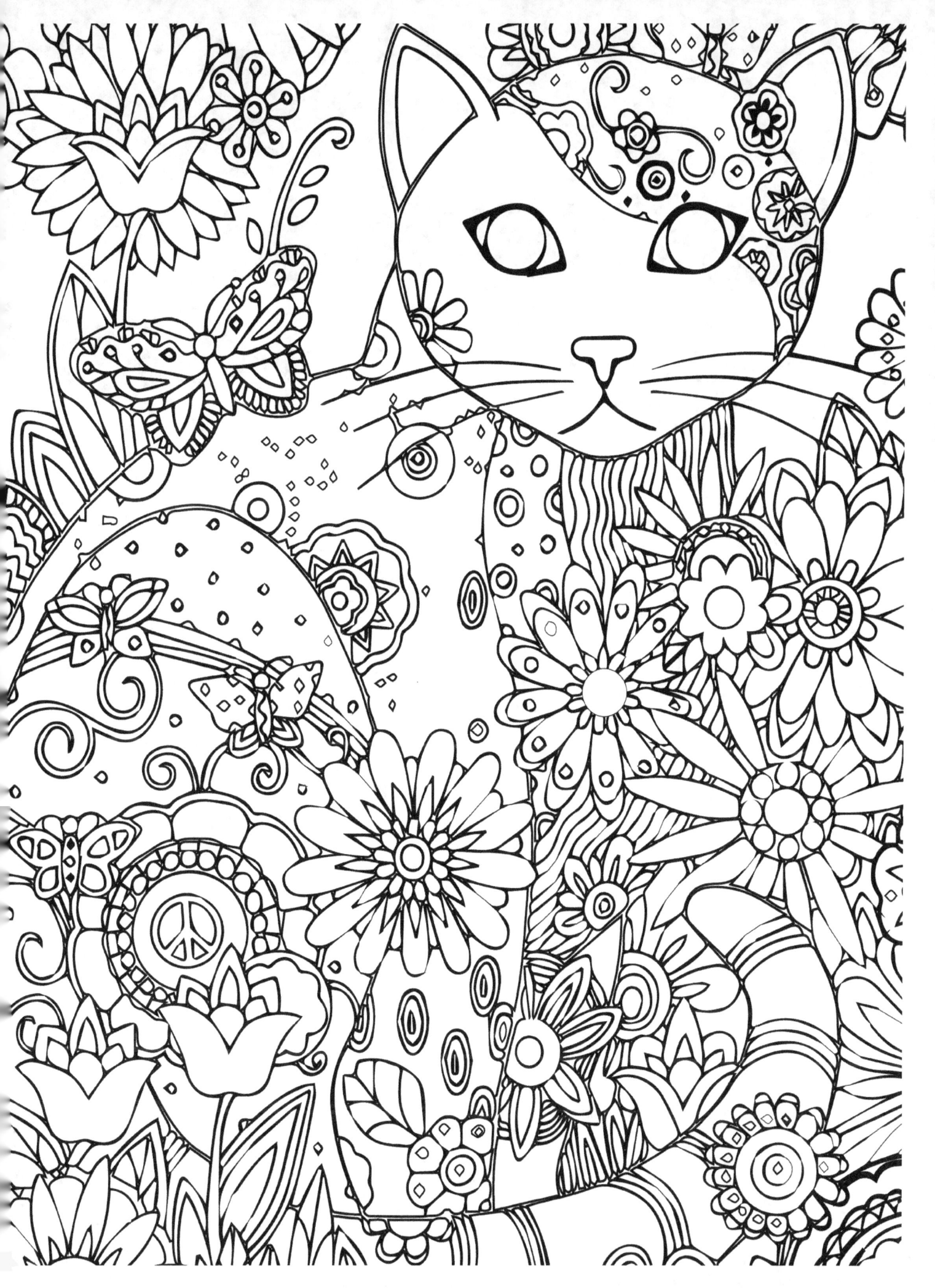

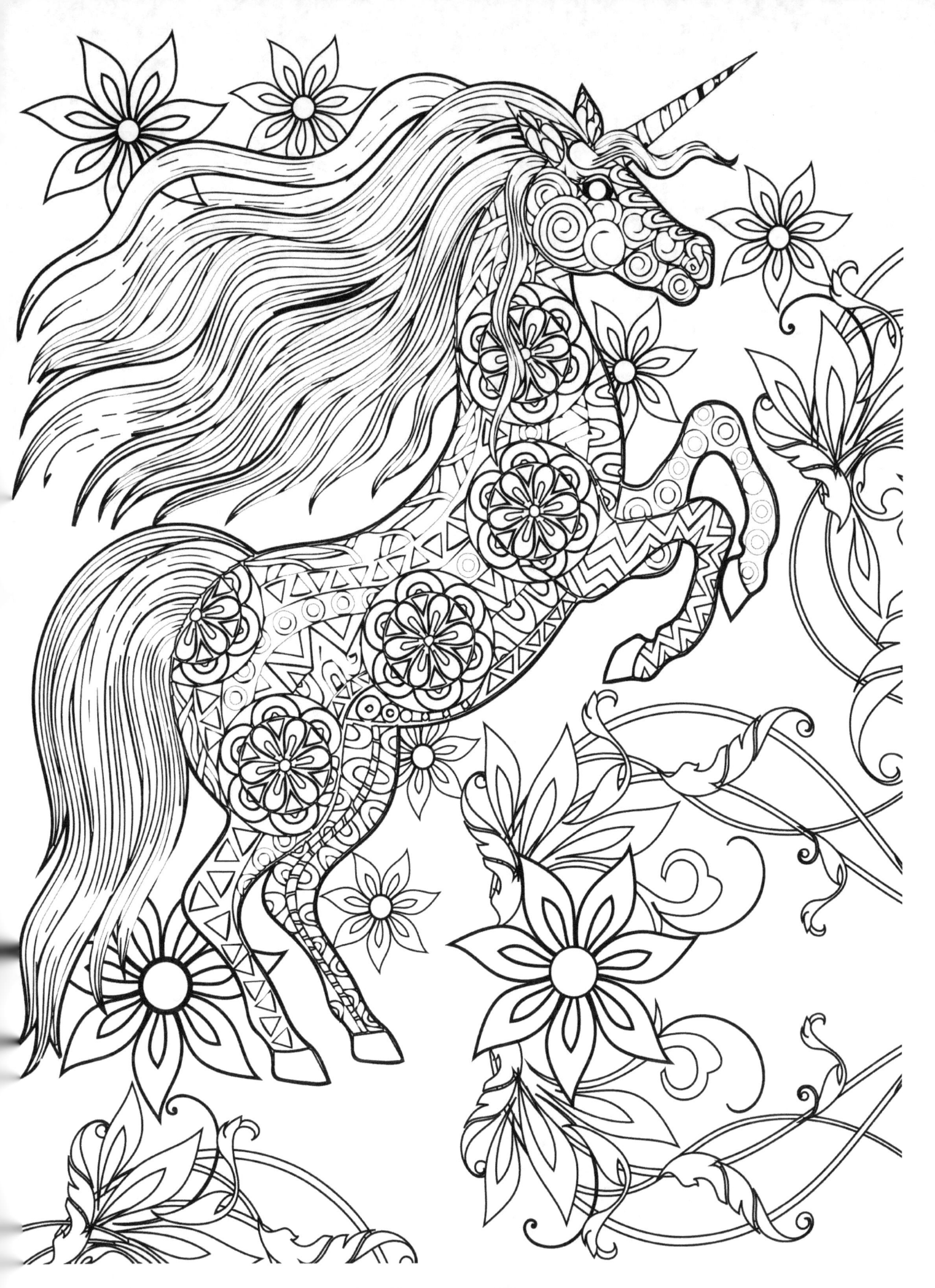